IMAGES
of America

FOREST HILLS

On the cover: The welcome wagon made people feel at home in Forest Hills. This 1949 photograph shows Lorraine Brucker Matusz (left) greeting John Haldeman in front of his father Hershel's Ford dealership. John made the borough proud by being one of the first Allied soldiers to cross into Germany at the end of World War II. He was also one of the few Americans decorated by British field marshal Sir Bernard Montgomery. (Courtesy of Art and Betty Haldeman.)

IMAGES
of America

FOREST HILLS

Jody B. Shapiro and Joel A. Bloom

ARCADIA
PUBLISHING

Published by Arcadia Publishing
Charleston SC, Chicago IL, Portsmouth NH, San Francisco CA

Printed in the United States of America

Library of Congress Catalog Card Number: 2006938613

For all general information contact Arcadia Publishing at:
Telephone 843-853-2070
Fax 843-853-0044
E-mail sales@arcadiapublishing.com
For customer service and orders:
Toll-Free 1-888-313-2665

Visit us on the Internet at www.arcadiapublishing.com

*First, last, and always in our hearts, we dedicate this with love
and gratitude to our parents, Alice, Arnold (in loving memory),
Diane, and Irving, our siblings, our siblings-in-law, our nieces
and nephews, and all of our dear friends.*

CONTENTS

ACKNOWLEDGMENTS

We are truly grateful to all those in and around Forest Hills who have been so supportive, friendly, talkative, and generous with their photographs and memories.

We would like to thank (alphabetically) Emillie Arbutina, Grace Bialon, Sally Bogie and the staff at Edgewood Library, Bob Brindley, Virginia Brindley, Vivian Broz, Patty (Wyche) Calore, Roland Catarinella, Mike Clark, Dolores Colella, John and Charlotte Coltman, Peggy Conrad of the *Woodland Progress*, Audie DiLucente, Jerianne Dodaro, Betty Evans, Gail Evans-Potter, Harold Frazier, Kline and Toni Fulton, borough arborist Ted Gilbert, *Golden Jubilee Book* and all who compiled it, Art and Betty Haldeman, Elizabeth and Jim Hanzel, Virginia Headrick, Mayor Ray Heller Jr., Fire Chief Ray Heller Sr., Marian Hershman, Marian Horsmon, Dorothy Hudak, Joy Humbert, Fr. Michael Kallaur, Alan and Faith Katchmar, Mike Kelly, Pete and Rose Kliment, Patrick Lanigan and his staff, John Lloyd, Joyce and Tom Lloyd, Dave Mann, Lorraine Matusz, Maria McCool and the Woodland Hills School District, Pat McCoy, Jack McGregor, officer Len Mesarchik, Mary Louise Milligan Rasmuson and the staff at the Rasmuson Foundation, Gretchen Milton, Steve Morus and everyone at the borough's front office, Judge Lester Nauhaus, Tom Nunnally, Rev. A. David Paul, Betsy (Langford) Peck, Graham Pinder, Kay Powderly, Shirley Ratner, Ruth Roth, Ed Sanders, Donald and Elaine Scheffer, Helen Schratz, Linda Schultz, George and Mildred Schultz, Alice Shapiro, Carmel Ann Shapiro-Bloom, Gina Silvestri, Cindy Simm, Fr. John Skirtich and Judy Kosar at the St. Maurice Parish office, Nina Stahlberg, Theodora Stupakis, Janet Sullivan, Lindsay Sullivan, Vince Taglieri, Frank Turoczy, J. P. Tyke, Katherine and Michael Vacsulka, Erin Vosgien at Arcadia for being such a great editor, Rob Wagner, Lee Walton, Terry Walton, William C. Weaver, Roger Wentworth's estate and the Forest Hills Rotary Club, which allowed us to have access to his historical documents and photographs, Bob Wolfe, and anyone we inadvertently missed. Any slight was not intentional.

A few images might be recognized from their appearance in the borough's 1969 *Golden Jubilee Book*. Using the original photographs, we were able to present the people and landmarks from a fresh perspective. We regret that we were unable, due to space limitations, to include every important face and place in the borough.

We want to thank each other for making this whole process so much fun!

INTRODUCTION

The history of Forest Hills started well before its 1919 incorporation. *The Saga of Forest Hills*, compiled as a project for the women's club in 1934 by Mrs. Arthur J. Jackman, traces the history of the area from the mid-1700s through to the court-approved incorporation. Jackman, who lived in the borough between 1923 and 1946, derived *The Saga* from the records of Freehold Real Estate. Freehold's president, J. William Brass, was one of the primary landowners and developers of the area.

The land currently known as Forest Hills was situated almost in the center of the area between the Great Stage Road (now Greensburg Pike) to the north, Turtle Creek to the southwest, and the Monongahela River to the south. Borders for this prime land were created by a series of divisions.

The first division was when 300-acre lots were formed between what would become the city of Pittsburgh to the southwest and present-day Wilkins Township to the northwest. Allegheny County, which Forest Hills is today part of, was carved out of parts of Westmoreland and Washington Counties in 1788. Allegheny was divided into townships, and the land that is now Forest Hills was in Pitt Township. Pitt Township was divided up in 1812, and Wilkins Township encompassed what is now known as Wilkins, Forest Hills, Churchill, and Chalfant. Further land divisions occurred in 1885, when current Forest Hills was divided between Wilkins and Braddock.

Settlers living near what is now Ardmore Boulevard were concerned that they were not getting fair representation of their tax dollars from Wilkins Township for maintenance of roads and schools. Talk about secession from Wilkins and Braddock began in earnest, and after what Jackman described as "bitter opposition" by the two parent townships, Forest Hills won a court battle for incorporation on July 29, 1919. The founding fathers then started building the borough of Forest Hills.

One

BUILDING A BOROUGH

Many building blocks played a part in creating Forest Hills. There were the large employers such as Duquesne Coal Company and Westinghouse, whose workers lived in the Ardmore neighborhood. Also of importance to building the borough were the founding fathers—the original council members and those who fought to establish Forest Hills as an entity separate from Wilkins Township. The foundation blocks of the main business district were those who dared, and succeeded, in establishing businesses along what they hoped would become a busy road. Herman Theilacker started his coal delivery business using a wagon before he acquired trucks. John Onufer Sr. moved some of Forest Hills Transfer and Storage's earliest customers using a pickup truck. And it took the vision and financial risk taking of developers such as Freehold Real Estate to build and expand neighborhoods like Bryn Mawr and later Edgewood Acres.

But the most important building blocks in putting together the community were undoubtedly, and still are, the people who lived here. Without the farmers, coal miners, and laborers, there would not have been patrons for any of the early businesses along Ardmore Boulevard. It was, and still is, the people who lived in the houses, paid the taxes, voted for council, attended churches, and were neighbors to each other.

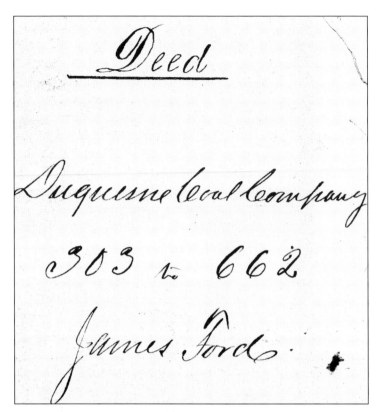

In the late 1800s, the Duquesne Coal Company operated mines beneath much of Wilkins Township, including what is now Forest Hills. It also made money from the surface. This March 13, 1873, deed, signed by company president Alexander Gordon, details the sale of Lot 53 to James Ford for $450. Hand-drawn plot plans in the county recorder of deeds office show the lot's location as being near the Forest Hills/Churchill border.

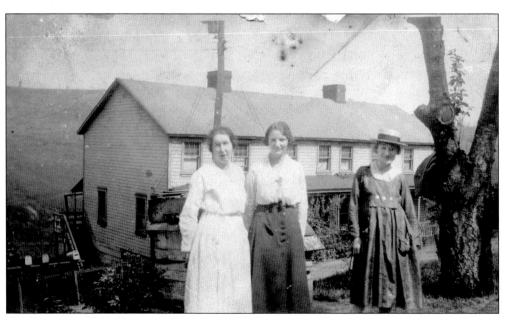

The Duquesne Coal Company did not sell off all its assets. The owners also kept some houses for use by their employees. One of these company houses was at 533 Filmore Road. The three women in this photograph, taken around 1900, are not identified. The building was torn down in 1960.

The Freehold Real Estate Company management knew how to spot economic opportunity. With the 87 Ardmore streetcar transporting Westinghouse employees through Forest Hills, the area was ripe for development as a commuter town. Freehold's earliest houses were small lots in the Ardmore area in 1907. Subsequent properties in the Bryn Mawr area were built after 1910. By the time Graham Bright's family moved to Bryn Mawr in 1913, there were barely a dozen homes in the neighborhood. Real growth, however, was just around the corner. The two images shown here, the cover of the *Bryn Mawr Plan* and a section of map from inside the booklet, illustrate the organization and planning that solidified Freehold's base.

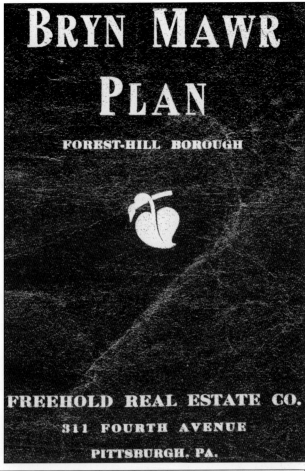

BRYN MAWR PLAN

FOREST-HILL BOROUGH

FREEHOLD REAL ESTATE CO.

311 FOURTH AVENUE

PITTSBURGH. PA.

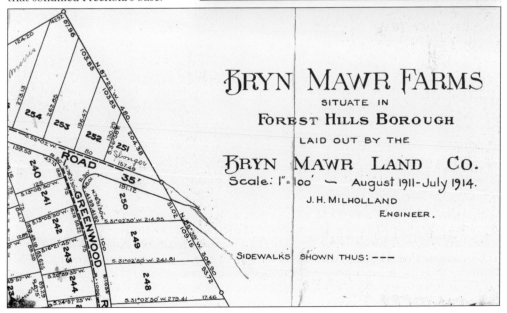

BRYN MAWR FARMS

SITUATE IN

FOREST HILLS BOROUGH

LAID OUT BY THE

BRYN MAWR LAND CO.

Scale: 1"=100' — August 1911-July 1914.

J. H. MILHOLLAND
ENGINEER.

SIDEWALKS SHOWN THUS: ---

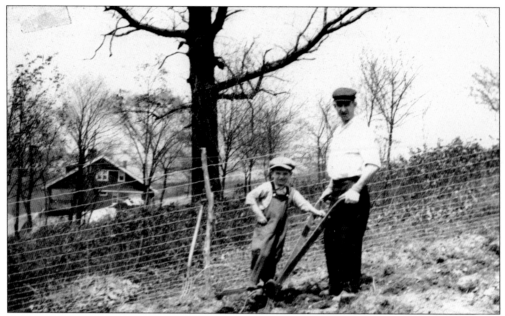

Graham Bright, an early Bryn Mawr resident, wrote in his 1955 history that the area was "farm land in which actual farming had ceased" by around 1900. Some residents, however, maintained their farms. This 1917 photograph shows George M. Graham (right) and his son George C. Graham working a hand plow on their farm off Woodside Road.

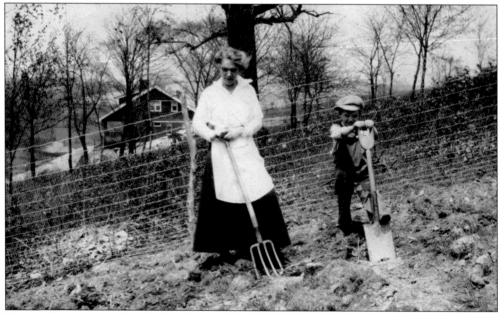

Despite the convenience of sidewalks in Bryn Mawr on many roads such as Bryn Mawr, Cherry Valley, and Woodside Roads, the roads themselves remained muddy and unpaved until borough incorporation. Utilities were available, although water supply was unsatisfactory in sparsely populated areas like Woodside, where Olive Graham (left) is shown in this 1917 photograph with her son George. Completion of Woodside Elementary School in 1914 prompted the necessary improvements to the water supply.

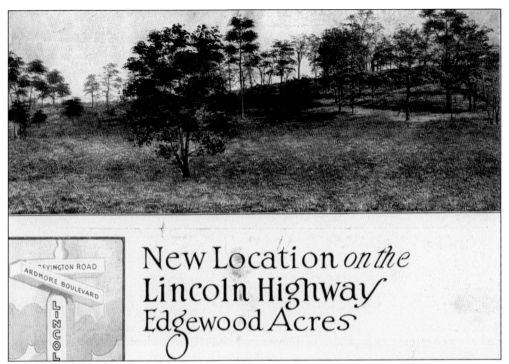

New Location *on the* Lincoln Highway Edgewood Acres

Freehold Real Estate was one of the earliest companies to sell homes in different areas of Forest Hills. These panels are from a pamphlet Freehold used in the late 1930s to market its homes for sale in the Edgewood Acres area. The bottom half is the front cover, where the address and postage were added. The top half, once folded, was the back cover.

The Freehold Real Estate pamphlet folds out to tell prospective buyers about Edgewood Acres as "an established community of high-class homes" that house "leading business and professional men" as well as "prominent doctors." This section of the foldout map shows part of the street plan. Notice Ardmore Boulevard in the center. Being so close to this major commuter route, with convenient public transportation to Pittsburgh, was an important selling point.

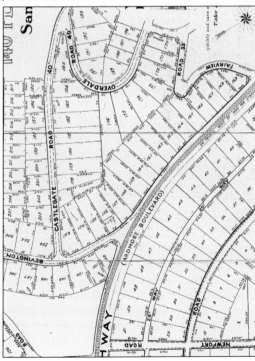

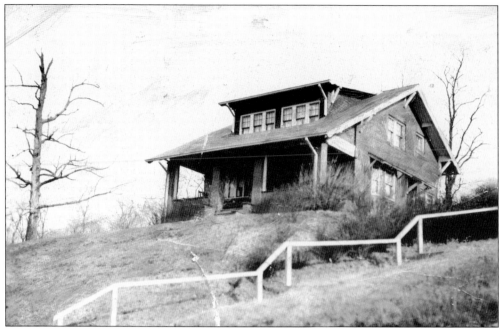

Some of the very earliest homes in Forest Hills are still standing. The Bryn Mawr neighborhood is on the hill leading up from the western end of Ardmore Boulevard toward Greensburg Pike. It was here that George and Olive Graham made their home, which still stands at 615 Woodside Road, shown in this 1917 photograph.

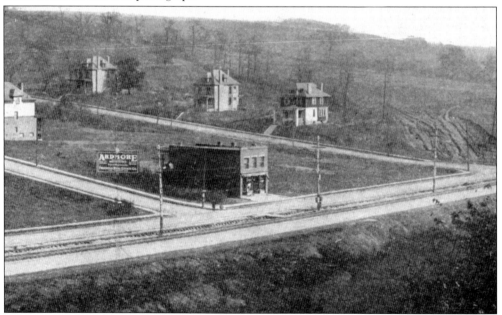

The Bissel building at 2203 Ardmore Boulevard is the oldest remaining permanent structure on the street, dating from the very early 1900s. A number of businesses, including the local library, have been at this location, which currently is an Allstate insurance office. This view of the building is taken from a panoramic photograph of the entire block. At the right of the photograph is the excavation for what is now Avenue K.

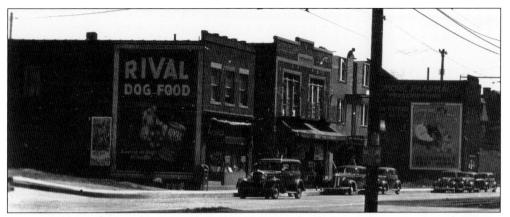

This photograph, dated 1942, shows the main business district on Ardmore Boulevard. Most of the buildings shown here are still in use. The Bissel building housed a market owned by Bissel and Cullen (left). The store sold Rival Dog Food and Gorton's Codfish. The Guiffre Building (center) still stands. Al Reiner's Ardmore Pharmacy, at the end of the block (far right), offered delivery service for prescriptions.

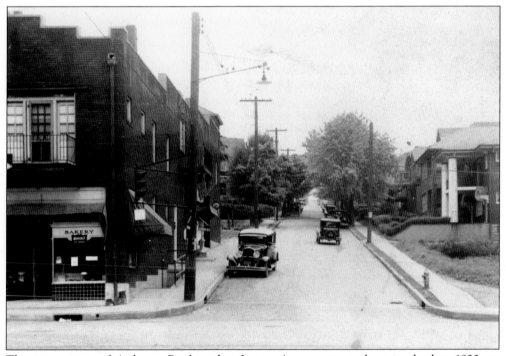

The intersection of Ardmore Boulevard at Lenox Avenue was as busy in the late 1920s as it is today. The bakery/post office (owned by Amelia Koch) on the left is currently home to Veltre's Pizza and still sports the black-and-white tile. The vacant lot on the right, where for years Christmas trees were sold, is now the location of Forest Hills Coffee Company and Shear Beauty hair salon.

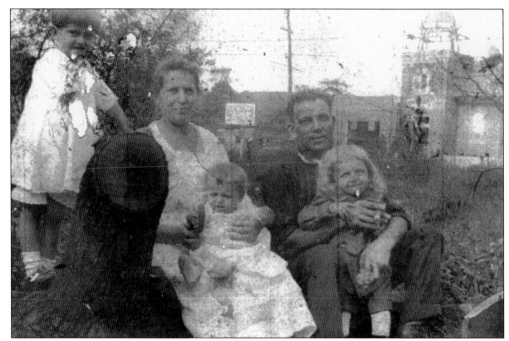

Pete Kliment Sr. (right) is pictured outside his service station and house on Ardmore Boulevard in 1922 with his son Pete Jr. on his lap. The newly opened municipal building with the original cupola is visible across the road. Also pictured are Pete's daughters Margaret (left) and Anna, and wife, Anna.

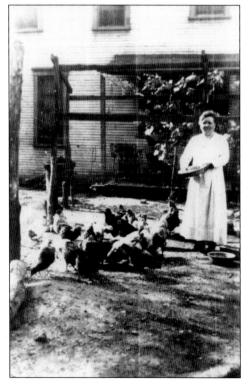

Agatha and Joseph Semethy lived on Berkeley Avenue from 1918 to the 1940s. Agatha is pictured feeding her chickens. Joseph had an impressive garden after he retired from Westinghouse. He spent his time tending flowers, fruit trees, and tobacco, which he used for his own cigarettes. Semethy grandson Carl Chada, also of Forest Hills, was credited in 1968 with inventing the Electronic Cricket remote car starter while working for Westinghouse.

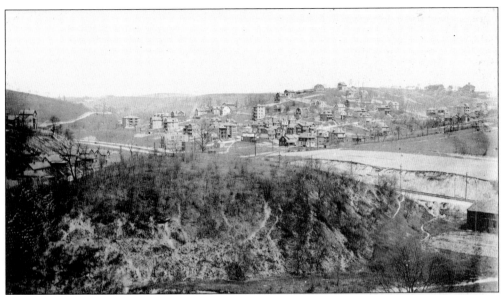

Anyone familiar with Yost Boulevard during the early 20th century would not recognize even the land in 2006. The large tree-covered hill, shown in the photograph above, was leveled so the Ardmore Shopping Center could be built in 1956. The mound had been an unauthorized playground of caves and trails known to some kids as "Thumbo Hill." Across Ardmore Boulevard and up the hill to the right are early homes in the Westinghouse Plan. O. P. Hipple, under the supervision of Westinghouse, managed the development of the housing plan in 1919. Located around the Westinghouse research facility, the plan was designed for employee homes. The photograph below shows the back of the mound viewed from the Ardmore neighborhood. The houses are along Yost heading up the hill toward Braddock Hills. Some daring people used to toboggan down Yost all the way to Ardmore Boulevard.

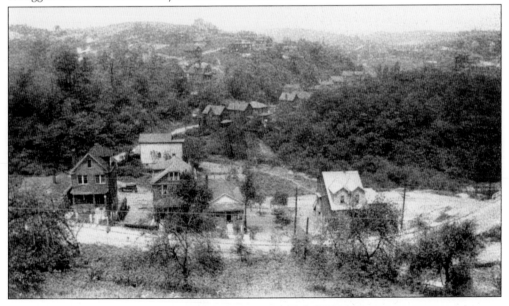

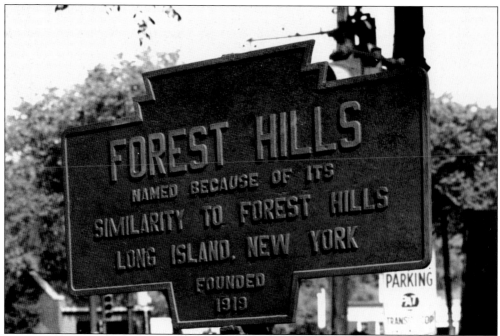

A historical marker greets eastbound travelers, indicating Forest Hills was "named because of its similarity to Forest Hills Long Island, New York." Topographically the two towns are quite different. The name may have come about because of the Tudor architecture that graces the New York Forest Hills and its similarity to that in Edgewood Acres. The name Forest Hills suits the borough, which features a steep, hilly terrain and countless trees.

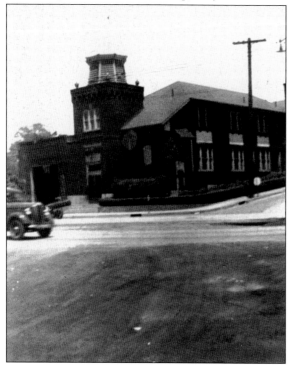

Forest Hills Municipal Building, pictured in January 1931, still stands at the corner of Ardmore Boulevard and Marion Avenue. Built in 1922 at a cost of $25,000, the building featured a distinctive cupola, which was removed in the 1960s when the fire siren inside the cupola was relocated. The garage at the left corner of the building housed the lone fire truck.

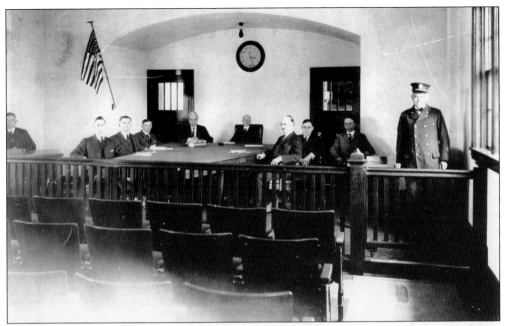

The borough council meeting room has been changed around, and around, a few times. In this photograph, believed to be from the late 1920s or early 1930s, the council is sitting at the end of the room closest to Ardmore Boulevard. The table, still in use by the present council, has switched ends of the room more than once as the room underwent various renovations.

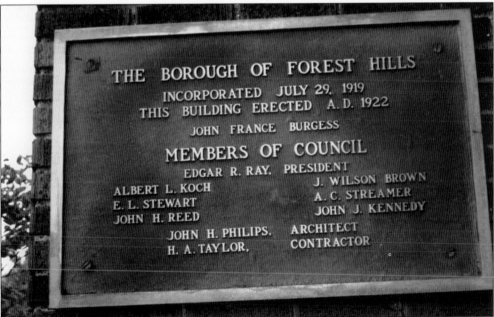

A plaque commemorating the 1922 completion of the municipal building and the first borough council is located outside the entrance. The plaque lists the building architect (John H. Philips) and the contractor (H. A. Taylor), as well as the names of the first burgess (John France) and council members, Pres. Edgar R. Ray, Albert L. Koch, E. L. Stewart, John H. Reed, J. Wilson Brown, A. C. Streamer, and John J. Kennedy.

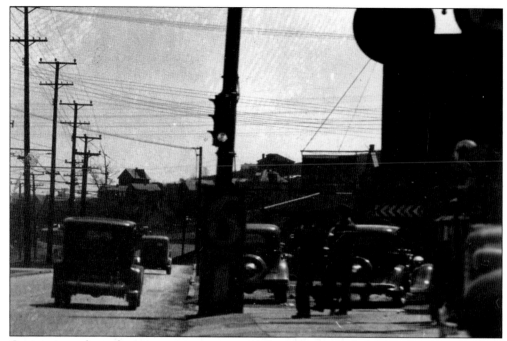

Gas stations along the commuter route to and from Pittsburgh helped make this stretch of Ardmore the main business strip. The service station in this 1942 picture was on the eastbound side of Ardmore Boulevard. The signs at the far right feature the Texaco Star and Fleet Wing oil logos. The Forest Hills Auditorium bowling alley is visible behind the service station.

Pete Kliment Jr. and his brother Joe are in the foreground of this 1938 picture taken outside their father's service station and house on Ardmore Boulevard. The municipal building is across the road. From left to right are Pete Kliment Jr., Eddie Schmidt, Joe Kliment, and Junior Panek. Pete Jr. and his wife, Rose, still live in the building, where Pete was born.

Freehold Real Estate, headquartered in Edgewood Acres at Ardmore Boulevard and Bevington Road, made a push to expand the neighborhood westward in the late 1930s and early 1940s. The bare, hilly terrain is shown in the 1940 photograph at right, when many of the marketed lots were unsold and empty, with only a few homes dotting the ridge. Part of Cascade Road, in the 1940 photograph below, is shown under construction early during the expansion. For the last several years, the neighborhood has hosted a huge multifamily yard sale on winding, tree-lined streets that had not yet developed at the time of these early images of the area.

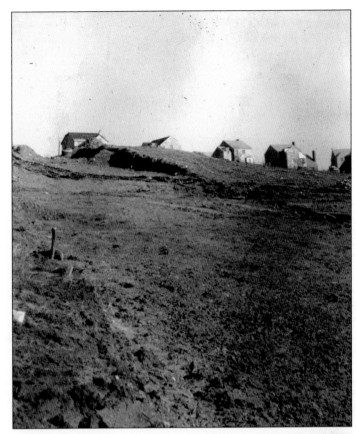

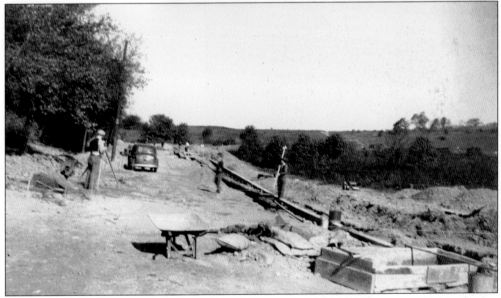

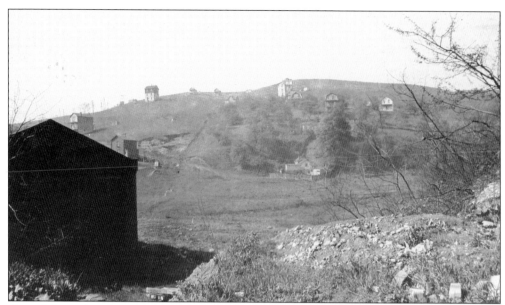

One of the earliest homes in the Ardmore section of Forest Hills, the Baker-Stewart house on Marwood Road looks up the hill toward where the Grandview Golf Course now sits on the ridge. The photographer was standing on Ardmore Boulevard looking toward Braddock. Yost Boulevard is a few dozen yards to the right. The houses dotting the hillside are in what is now considered North Braddock.

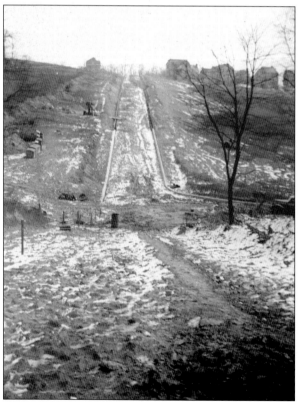

Another example of the Edgewood Acres expansion, Edgewood Avenue horseshoes around above Ryan Glen Park leading to the overlook above Ardmore Boulevard. This point near the western border with Braddock Hills has recently needed to fight to remain a residential area; companies have tried to use the flatness of the ridge for commerce, including a car storage lot.

A great deal of heavy equipment and machinery was needed to build the roads and clear the lots on which to place houses. The workers did not stop because of snow. Longtime area contractor Rochez Brothers' equipment is pictured in the foreground of this photograph of Washington Road in 1940.

This 1940 photograph shows a road crew installing curbs on Morrow Road in the Bryn Mawr neighborhood. With the hilly terrain came lots of mud and impassable roads. Curbs, sidewalks, and road paving were just the first steps to successful neighborhood development.

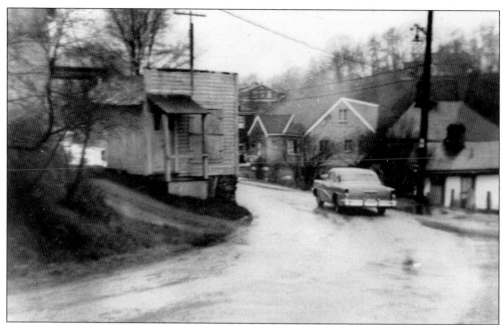

When she was the owner, Mary Murray worked from 9:00 a.m. to 10:00 p.m. in this little general store, supplying candy, lamp oil, and salty fish for miners. Located in the Mucklerat neighborhood, at the corner of Braddock and Glasgow Roads, the building is pictured here from two views in the 1950s, shortly before it was torn down. The area above the store, stretching from Braddock Road to what is now Roberta Drive, was leased out by the Duquesne Coal Company as farmland through the 1940s. Goats and other farm animals would often wander down to Braddock Road. The Central Sites area, where Trinity Christian School is now, had a baseball field where organized leagues and pickup teams played. Today the Parkway Heights area is a mix of older and newer homes, Hope Lutheran Church, and the school.

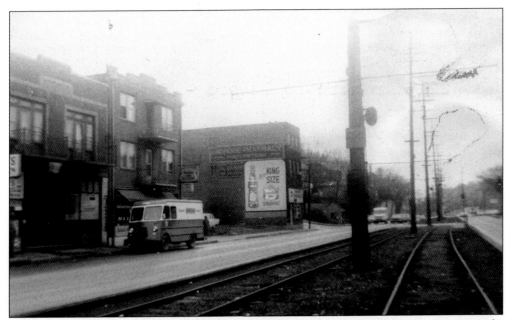

Throughout the 1960s, residents did not have to go far for groceries, a newspaper, penny candy, or a bottle of pop. This 1961 photograph of Ardmore Boulevard shows Spinelli's Fruit Market (far left). Spinelli's featured Meadow Gold Ice Cream. Braun's Town Talk Bread was delivered fresh. Ted's Variety Store was two doors down. Al Reiner's Ardmore Pharmacy, at the end of the block, featured the new king-size glass bottles of Canada Dry Ginger Ale.

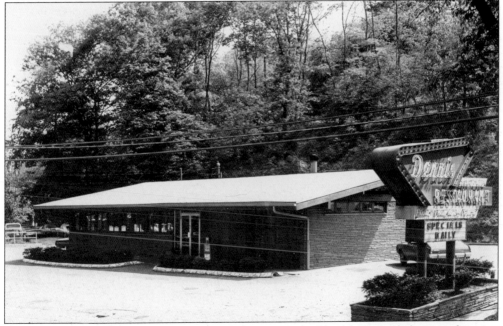

Dennis' Restaurant (now Drew's), pictured here in 1969, had long been settled into its location across from Filmore Road, after having moved from near the intersection of Ardmore and Yost Boulevards. Residents could have a quick meal there, or at the Plaza Restaurant located in the new Forest Hills Plaza Shopping Center or the Village Dairy in Ardmore Shopping Center.

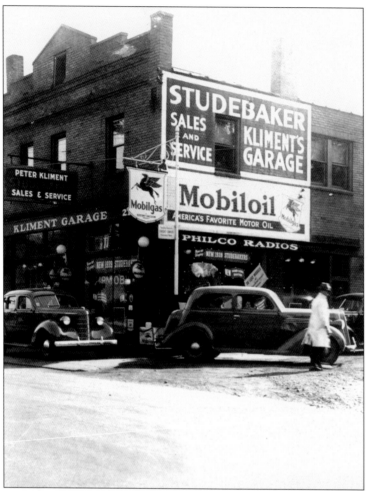

Businesses came and went along Ardmore Boulevard. Three of the longest active businesses, Kliment's automobile sales, service, and gasoline (pictured to the left in the 1920s), Forest Hills Motors (pictured below in the 1970s), and Forest Hills Transfer and Storage (not pictured), were neighborhood landmarks for most of the 20th century. Forest Hills Transfer and Storage, built in the 1920s, is the only business of the three still in operation in 2007. Located at 2101 Ardmore Boulevard, Forest Hills Transfer's building and the building that formerly housed Kliment's both still stand. The Ford dealership was torn down in 1993, and a Taco Bell was built.

Brucker Hardware was a fixture at 2143 Ardmore Boulevard for many years. Opened in 1952 by Anthony Brucker, the store was a one-stop shop for hardware and plumbing supplies. Brucker's children took over the shop after his 1971 death. A role model of how to give back to the community, Brucker had served on council and had been very active in the Rotary Club.

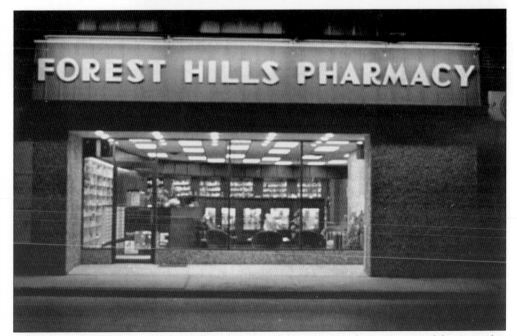

The 1972 postcard of Forest Hills Pharmacy was used to announce the reopening of the store after a fire. The storefront, located on Ardmore Boulevard in the Mai Building, changed hands several times and recently underwent a face-lift. Since 2005, it has been home to an antiques/gift shop.

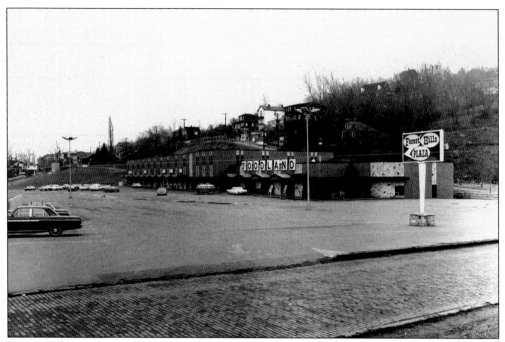

Forest Hills experienced a boom of construction in the mid-1960s. The Ardmore Garden Apartments were built in 1965. Groundbreaking for the Parkway Center East office complex was in 1967. The complex, which has retail and office space, sits on 23 acres fronting Ardmore Boulevard. The Cost brothers' company built the Forest Hills Plaza Shopping Center (pictured here) in 1966–1967. Retail spaces and offices were included in the development.

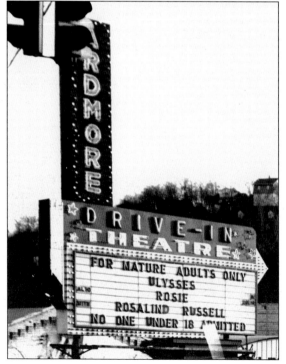

Although the Ardmore Drive-In Theatre was in Braddock Hills, the sign directing movie watchers sat at the intersection of Ardmore and Yost Boulevards. Moviegoers from around the area would load up the car to see the latest movies. When the theater closed, a strip mall featuring a Giant Eagle and Gold Circle was built. The Giant Eagle still stands; the Gold Circle was replaced by a Builders Square, which later closed.

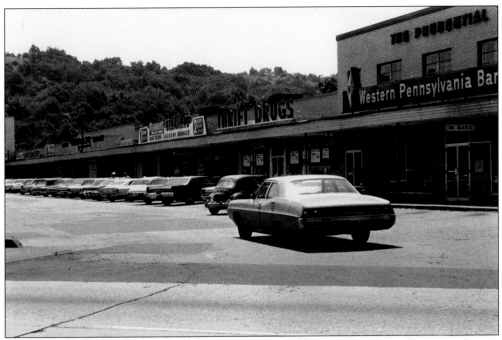

Developers literally moved a small mountain when building the Ardmore Shopping Center, which opened in 1956. Constructed by the Mellon-Stuart Company, the shopping center still stands in 2006, after a recent makeover. None of the original stores are still there; however, a new Aldi grocery store occupies the location of the former Thoroughfare Market. These 1968 pictures show two views of the strip mall. Residents could bank at Western Pennsylvania Bank, get insurance at the Prudential, buy groceries from the Thoroughfare or A&P, or get their dry cleaning from Runner's. They picked up a prescription at Thrift Drugs, bought fabric or candy at Autenreith's (five-and-dime), bought a piece of jewelry at Marlen's, had their hair cut at Vi's Beauty Salon, or bought cake, cookies, and a card at Nill's Bakery and Memory Lane Hallmark shop.

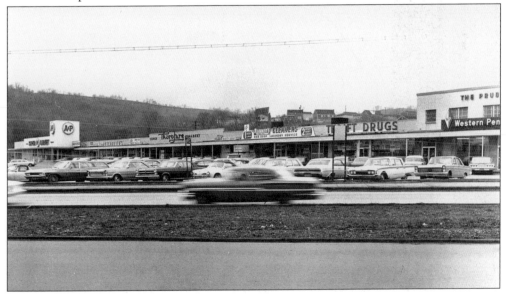

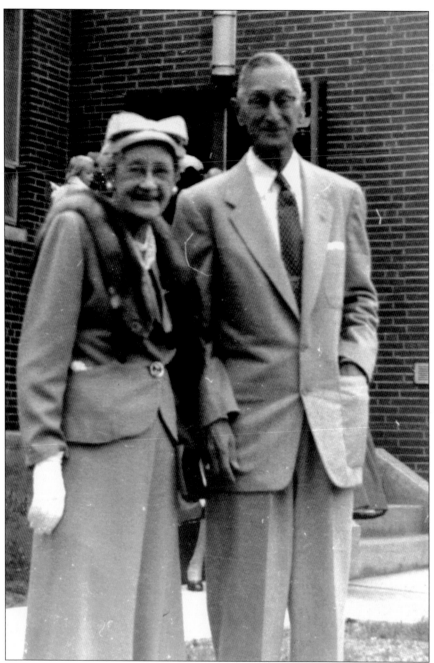

Pictured here is one of Forest Hills' founding fathers, Al Koch (right) and his wife, Amelia, taken in the early 1960s. Al's name can be found in historical documents from before the borough was even a borough. Al was on the original borough council, was the third burgess, and was the first mayor. His career in public service spanned over 45 years, from 1919 to 1965. Al was also involved in the 1923 incorporation of Forest Hills Presbyterian Church. The family owned a bakery at Ardmore Boulevard and Lenox Avenue that briefly housed a post office, which Amelia ran, while Al was postmaster. The Koch family also owned the Forest Hills Auditorium bowling alley and two apartment buildings on Ardmore Boulevard.

A testimonial retirement dinner was held in Al Koch's honor at Churchill Valley Country Club on February 17, 1966. Almost 500 people attended the celebration. That same year a new park, located at the end of "new" Atlantic Avenue, was named in his honor. The land for the park, given to the borough by local developer Roland Catarinella, was the site of a former golf course.

Testimonial Dinner

HONORING

Albert L. Koch

FOREST HILLS, PA.

Churchill Valley Country Club

THURSDAY, FEBRUARY 17, 1966 — 6:30 P.M.

The first burgess of Forest Hills was John France, followed by Lee Wisner. Al Koch served as both a burgess and the first mayor. Subsequent mayors were Richard E. Wise (pictured here after his 1966 election), Al McCoy, Robert Disney, Elmer Incheck, Mary Ann Capezzuto, Frank Sabino, Ken Gormley, and Ray Heller Jr. Ray's brother Larry is a police officer in the borough. Their father, Ray Heller Sr., is the borough fire chief.

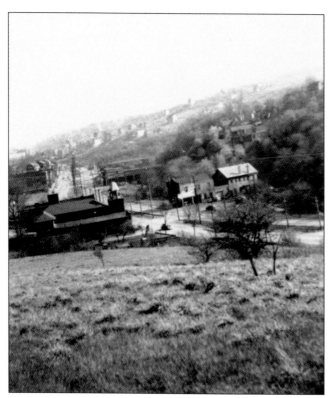

These two photographs, the one at left taken in the early 1950s and the lower one in 1983, are from almost the same location on Filmore Road, above Ardmore Boulevard. The changes over the 30 years are remarkable. In the photograph at left, the municipal building is on the left and Kliment's Studebaker dealership is on the right. The business district and houses on Berkley Avenue and in the Ardmore neighborhood are in the background. In the 1983 photograph, the municipal building and Kliment's can be seen along with the business district, the Mobil gas station and car wash and Arco gas stations are on the right. The Cost Building and offices at the Forest Hills Plaza Shopping Center can be seen in the background.

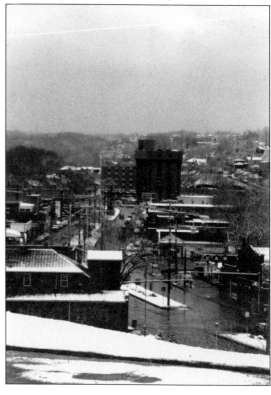

Two

HORSES' POWER
TO HORSEPOWER

Transportation played a significant role in the development of Forest Hills. In the early 1800s, Wilkins Township, including the area now known as Forest Hills, was surrounded by developing roads and paths. What is now the northern border of Forest Hills, Greensburg Pike was known as the Great Stage Road and later as the Greensburg Turnpike. The borough's southern border, Brinton Road, ran from the Brinton train station on the Braddock/Turtle Creek border and followed very close to its present course.

In 1913, the Lincoln Highway—the Gateway to the West—pushed through the area, and horses and wagons were soon replaced by the horsepower of automobiles. This road became a natural place to establish businesses such as restaurants and service stations, catering to the travelers and commuters. Eventually there would be over 10 gas stations on the stretch of the Lincoln Highway from Wilkinsburg to East Pittsburgh.

After sustaining heavy damage from military convoys during World War I, the stretch of the Lincoln Highway running through Forest Hills was renamed Ardmore Boulevard in 1920. According to the report in the Forest Hills jubilee book, the road was closed for nine months before reopening with fanfare and a parade, which stretched from Wilkinsburg to East Pittsburgh.

In 1925, the Lincoln Highway was included in the federally established numbering system of United States highways and was dubbed U.S. Route 30. A skinny concrete and stone marker with a large blue *L*, denoting the Lincoln Highway, still stands at the corner of Ardmore Boulevard at Yost Boulevard.

Over the years, Greensburg Pike and Ardmore Boulevard have been modernized by a series of widenings, the addition of traffic lights, and, for Ardmore Boulevard, the removal of the streetcar tracks. Ardmore Boulevard remains connected to Greensburg Pike and Brinton Road. Braddock Road is the only direct link between all three. Greensburg Pike had its share of travel-related businesses. At one point in the 1960s, Greensburg Pike was home to three gasoline/service stations, one car wash, and three restaurant/taverns. Brinton Road also had several gasoline service stations and restaurants.

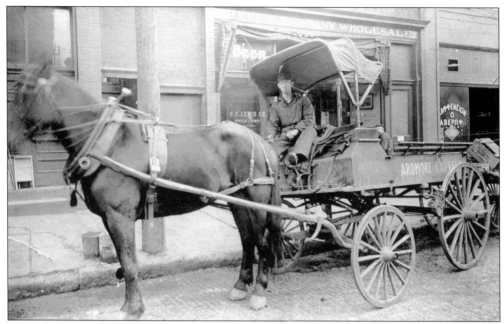

In the 1920s, when this photograph was taken, settlers to the area could have their groceries or beer delivered to their homes by horse and wagon. Vincent F. McCoy Sr., who lived on Filmore Road until the late 1940s, is pictured delivering beer from the Pittsburgh Brewing Company. The side of the wagon reads "Ardmore Express." McCoy worked the hilly terrain of Forest Hills and East Pittsburgh.

Horses were also used to help build houses. This house, which still stands, is located near the top of Braddock Road. Bernard T. Fierst dug out the foundation. Fierst used a horse to power the plow and to haul away the dirt.

Stagecoaches no longer traveled along Greensburg Pike in the 1940s when this picture was taken of the Esso station (now J. P. Tyke's Gulf station). The Fierst family bar and restaurant was located next to the gas station. Travelers would fill their tanks and eat at the restaurant. When the Fiersts sold the bar, it became Tavern on the Pike. An apartment building now stands on the site.

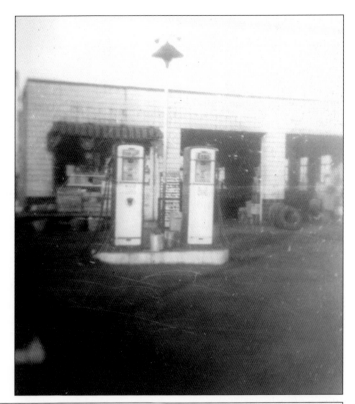

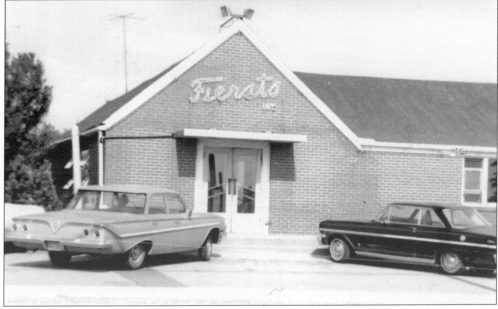

William Fierst's restaurant and bar (later Tavern on the Pike), shown in 1962, was located on Greensburg Pike at the Forest Hills/Churchill border. William also owned the Humble (later Esso) service station next door. In 1969, the service station was sold to J. P. Tyke. William's son Bernard managed and tended bar at Fiersts. In 2005, great-granddaughter Elizabeth Hanzel opened Little Dishes, a gourmet dessert shop in Forest Hills.

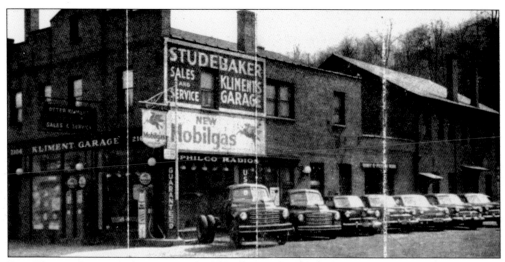

Pete Kliment Sr. repaired wagons and sold Miller gasoline from his Ardmore Boulevard garage in the early 1900s. As cars began replacing horses, Pete started selling Chalmers in 1910. He later sold Hupmobiles, Chandlers, and Clevelands. Kliment's, pictured here in 1940, is best known for selling Studebakers, which Pete sold until he retired in 1954 and his sons Pete Jr. and Joe took over the business.

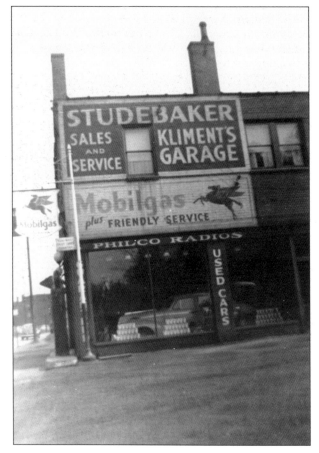

A 1942 Studebaker is pictured in the showroom at Kliment's. In addition to the automobile sales and gasoline, Pete Kliment Sr. operated a towing and automobile repair shop and sold Philco radios. When his sons took over, the primary focus of the business was repairs and towing. Pete Jr. and Joe repaired all makes and models of cars.

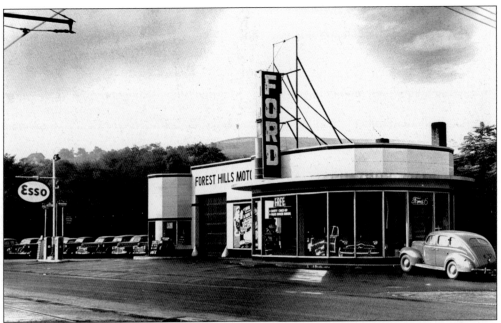

Centered between the Lincoln Highway (now Ardmore Boulevard/ U.S. Route 30) and Greensburg Pike, gas stations and car dealerships thrived in Forest Hills for most of the 20th century. Joe Rosso's Forest Hills Motors, on Ardmore Boulevard, was sold to the Haldeman family in 1935. This 1949 photograph shows the Ford dealership along with the Haldemans' Esso station. Changing hands in 1986, the building was torn down in 1993.

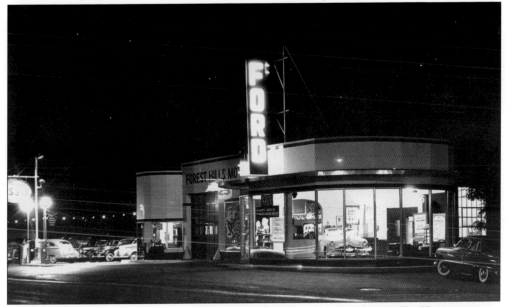

The 1932 Westinghouse Bridge opening increased traffic through Forest Hills. The impact can be seen in this 1940s photograph of Forest Hills Motors. The streetcar tracks run in front of the showroom. An Esso gas station is to the left of the dealership. Forest Hills Motors was one of three automobile dealers in the borough. Kelley's Oldsmobile dealership was one block down, and Kliment's was two blocks away.

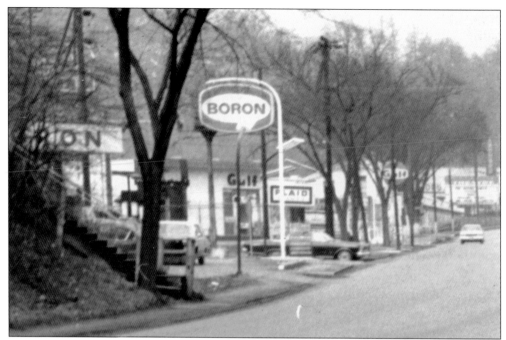

In the late 1960s into the 1970s, travelers going east or west along Route 30 would have their choice of gas stations. Eastbound drivers would be greeted by a Gulf station and had several choices before reaching the Boron station (pictured above in 1968—now a Domino's Pizza) at the Forest Hills/East Pittsburgh border. Coming into Forest Hills, heading west, travelers passed several gas stations before Wilkinsburg. Ed Katchmar's Gulf station (pictured below in the early 1970s—now an office building), located at Bryn Mawr Road, was the last stop for gas in the borough on this side of the road.

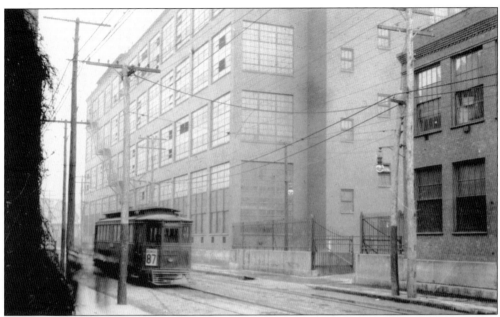

When the streetcar tracks were installed next to the burgeoning Lincoln Highway, workers from Wilkinsburg and Brushton traveled through the area on the way to work at the East Pittsburgh and Forest Hills Westinghouse facilities. The 87 Ardmore streetcar also carried students to high school in Wilkinsburg and to Kennywood Amusement Park for the annual school picnics. An early-20th-century 87 Ardmore is pictured here in East Pittsburgh.

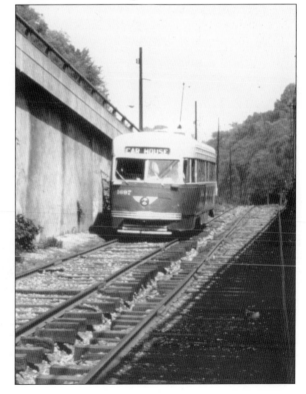

Those who remember the 87 Ardmore tell stories of taking it to Forbes Field in Oakland for a Pirates game or to attend school or shop in Wilkinsburg. When the route was expanded, shoppers would hop on the streetcar and head to downtown Pittsburgh. The streetcar in this photograph, from the late 1920s or early 1930s, is headed down the ramp to Electric Avenue from Ardmore Boulevard.

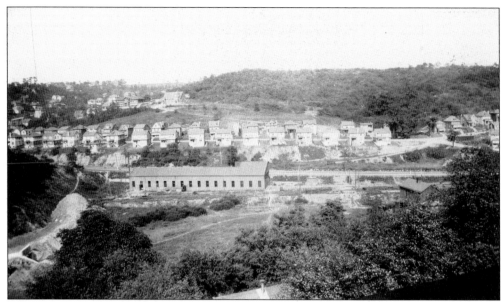

Before it became the Memory Lane Roller Rink (later Ardmore Roller Palace), the building at the lower left of this 1920s photograph was a streetcar barn. This corner in 2007 is the busy intersection of Ardmore and Yost Boulevards. When it was first opened, Yost Boulevard was brick, until it was paved in the late 1970s. Across the boulevard, houses can be seen on Sumner Avenue, Lenox Avenue, and Halsey Avenue.

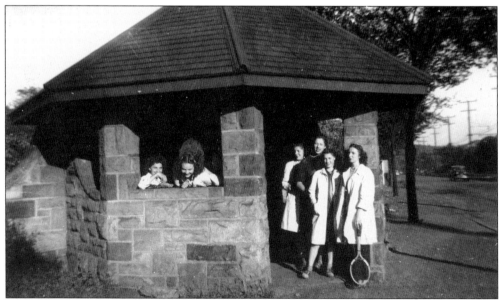

Lee Momo (Walton) (second from the left) and the unidentified women pose for this 1940s picture in the stone shelter at the intersection of Braddock Road and Ardmore Boulevard. This shelter, which still stands, originally served streetcar riders, and later bus riders. Penn Lincoln Parkway construction also began in the 1940s, and in 1948, Forest Hills residents had access to the new highway from a ramp off Ardmore Boulevard.

The 87 Ardmore streetcar route was extended to downtown Pittsburgh in 1937, via East Liberty and Liberty Avenues. After the last 87 Ardmore rolled down the tracks in September 1966, the tracks sat idle until removal began in 1968. These photographs, taken in 1968, show the intersection at Braddock Road and Ardmore Boulevard. When the tracks were removed, grass and trees were planted on the median. With the demise of the streetcar, bus travel became more popular for commuters. Lincoln Coaches had been running buses through the area since 1937. In the 1960s, the Port Authority of Allegheny County beefed up services. Commuters could take the Trafford or Lincoln Highway buses to Wilkinsburg, Oakland, or Pittsburgh. In 1983, the Martin Luther King Jr. Busway from Wilkinsburg to Pittsburgh opened. The commute for workers from Forest Hills and other eastern suburbs was significantly shortened.

To look at the intersection of Yost and Ardmore Boulevards in this 1968 photograph, it is hard to believe that this busy road, one of two direct connectors between Forest Hills and Braddock was, in the early 1900s, a private road leading to a family estate on Brinton Road. Yost Boulevard has undergone several face-lifts since this photograph was taken, including being widened and the addition of turning lanes onto Ardmore Boulevard.

In 1965, Ardmore Boulevard was asphalted. A 1973 planning commission called for improving the movement of vehicles and people on the road while keeping the tree-lined median. That year, traffic reached approximately 30,000 cars per day, causing congestion and exceeding the road's capacity. Over the next 10 years, Ardmore Boulevard was upgraded. Taken in the late 1960s, this view is looking east on Ardmore Boulevard from Filmore Road.

Three

WESTINGHOUSE AND KDKA

A town might be especially known for one event or another—a famous person or historic landmark. However, not many places as small as Forest Hills can claim to be the home of two truly world-changing events—two firsts. Radio was not born in Forest Hills. The work of Guglielmo Marconi and Nikola Tesla in the late 1800s predates Forest Hills by several decades. But KDKA started here, as the first licensed commercial station, thanks to the knowledge of Frank Conrad and the vision and nerve of Dr. H. P. Davis. Davis, a vice president at Westinghouse, was confident enough in advance of the first test broadcast in 1920 that he had Westinghouse-manufactured receivers advertised for sale at Joseph Horne's department store. The test was a huge success. KDKA was born and eventually grew into a television station and CBS network affiliate.

George Westinghouse's company was successful long before Forest Hills was even a borough. The East Pittsburgh facilities were in operation. The new research building opened in Forest Hills in 1916 and was poised to take Westinghouse to unheard of levels of research and development. In 1937, the Atom Smasher, located next to the Forest Hills research building, was unveiled to the world. Not the world's first particle accelerator but the first of this size and power, this huge lightbulb-shaped structure enabled researchers to move atomic particles at unprecedented speeds and voltages. Nuclear energy was opened up as an avenue of exploration and forever changed the way people lit their homes, cooked their food, and waged their wars.

The Westinghouse Electric and Manufacturing Company was already a successful entity in 1916, when the research laboratory in Forest Hills was opened. This was unique among large corporations in that it was separate from company manufacturing facilities, allowing for research that was more independent. This image of the original building was hand drawn by Dr. John Coltman, longtime research manager at Forest Hills. The research facility was moved to Churchill in 1956.

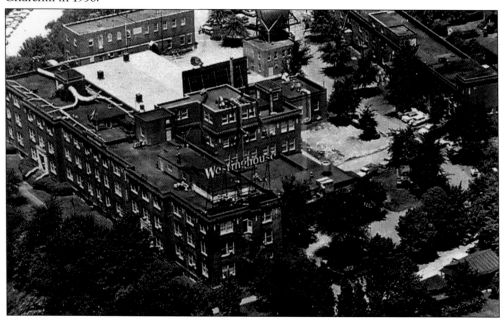

There were many products furthered by research done at the Forest Hills facility, shown here in this 1950s aerial shot. An early version of faxing was worked on in 1930. Perhaps the most significant and patriotic contributions occurred during World War II. The tank-gun stabilizer, which helped keep gun turrets steady, is one example. Also, work was done in microwave radio transmission, which aided in wartime use of radar.

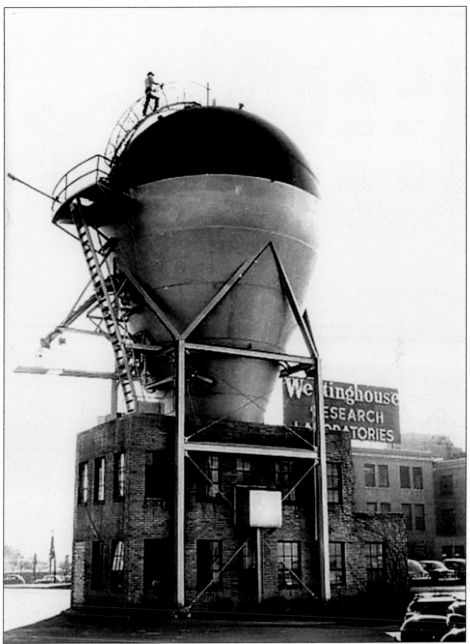

The most iconic image of Forest Hills is undoubtedly the Westinghouse Atom Smasher, shown in the 1950s. The Atom Smasher, a variation of a Van de Graaff generator, was designed by Dr. William H. Wells and unveiled in 1937. Westinghouse scientists had come to believe that nuclear physics was a field that could lead in innumerable directions. High-voltage nuclear particles were thought to be the key to success in chemical, medical, and other areas of research. The tank was built by Chicago Bridge and Iron. What was groundbreaking was the machine's power; it was capable of reaching five million volts. Timing was everything; Carnegie Tech and the Massachusetts Institute of Technology had also tried but not yet succeeded in developing a generator with this level and speed of energy. Westinghouse had won the race.

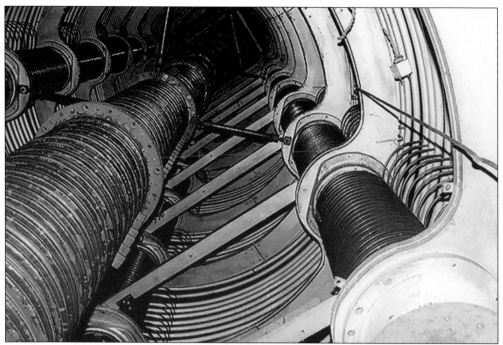

This dizzying view looks up to the top of the Westinghouse Atom Smasher from the inside. To gain perspective on the massive size of the machine, look back to the previous image to see the man on the ladder atop the outer tank. The top of the machine was 65 feet from the ground, and the internal pressure tank was 30 feet in diameter and 47 feet high.

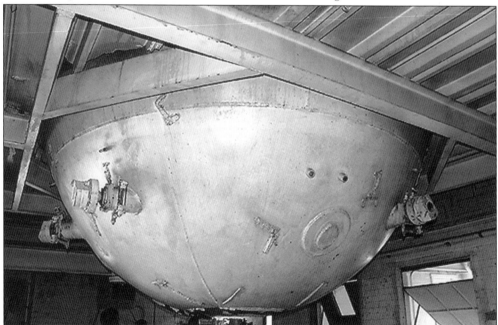

The bottom of the Atom Smasher inside the laboratory building that surrounded the machine is shown in this photograph. Targets for atomic bombardment were either just below the machine on the floor or in a well below the floor for extra shielding.

Westinghouse thrived into the 1970s and beyond. Although the Atom Smasher was not used past 1958, the familiar W in this 1970s photograph would symbolize a company of 13,000 employees supplying power plants worldwide. General Electric, with its boiling water reactor, had half the number of reactors as Westinghouse. France generated 60 percent of its electricity by nuclear means in the mid-1980s. Almost all of France's nuclear power was Westinghouse generated.

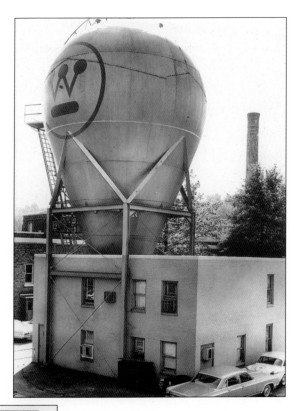

WELCOME TO WESTINGHOUSE

FELLOW EMPLOYES, FAMILY AND BOROUGH RESIDENTS:

It is a pleasure for me to welcome you to Family-Community Day at the R&D Center. We are proud of our employes, our facilities, the community we are located in, and our accomplishments.

I join with the more than 2,000 employes in the hope that you will enjoy your visit with us, and that you will become better acquainted with our work.

I hope you find your visit to the Research and Development Center interesting, enjoyable and informative.

Sincerely,

W. E. Shoupp
Vice President, Research

Westinghouse took great pride in being a family-oriented, community-friendly employer and neighbor. The 1969 version of Community Day was no exception, as the message on the program cover from Dr. W. E. Shoupp, vice president of research, shows. Held at the research center in nearby Churchill, the event was a chance for local workers, their families, and neighbors to enjoy one another's company, as well as learn about Westinghouse.

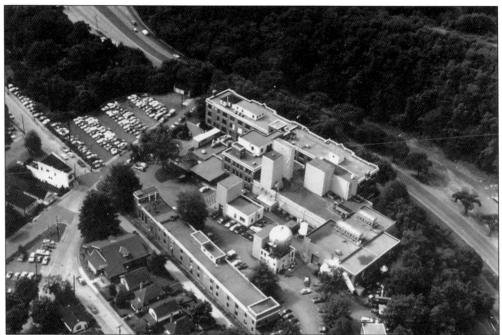

Although the research laboratory moved to Churchill in 1956, the Forest Hills facilities, shown in this 1970s aerial shot, were used until 1996, primarily for nuclear power testing and development. Westinghouse paid attention to workers' ideas as well. If workers had an idea thought worthy of exploration, they might be granted $10,000 to develop their experiment on their own time.

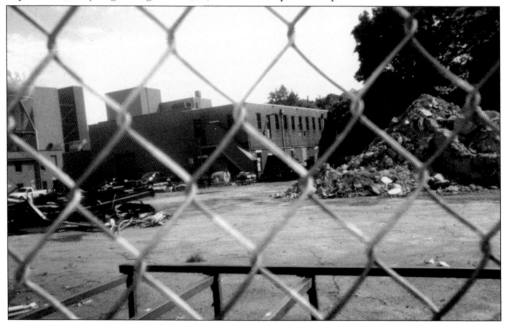

As difficult as it may be to see the Westinghouse Forest Hills plant through the chain-link fence in this 2004 photograph, it was next to impossible for former workers to imagine what they were seeing. Buildings were being torn down. Piles of rubble lay where world-changing experiments were once performed.

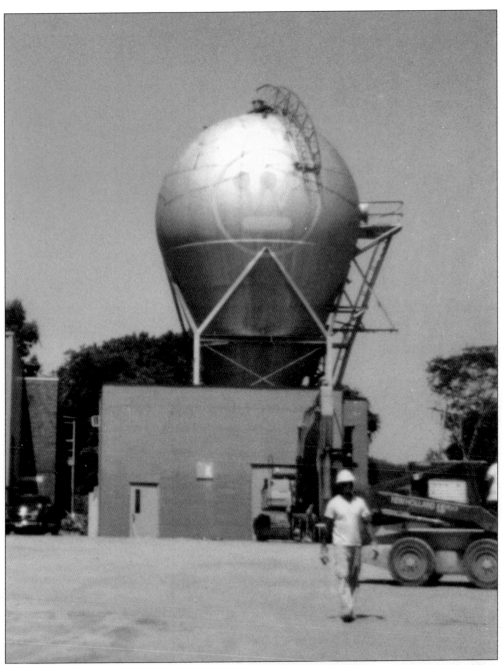

Despite the dismantling of the Forest Hills Westinghouse buildings, the Atom Smasher building is still standing. This photograph is from the demolition phase of the Westinghouse plant. It has historic landmark status, although what may be keeping it around is its sheer size. There have been efforts aimed at getting a museum or another industrial facility to accept custody of the structure. But these attempts have to date been unsuccessful. The huge structure makes neither display at another facility nor safe teardown cost-effective. Therefore, even though it would cost too much to move it to a museum, it seems destined to sit on the now empty lot where the research center once stood, in its own de facto museum.

Retirement parties were always, and still are, occasions to get together with former coworkers. This photograph was taken at the retirement party of Westinghouse employee Johnny Harper in 1988. Seated from left to right are Forest Hills resident Fritz Ottenheimer, Shep Bartanoff, and Dr. Jim Wright and his wife, Renell.

Westinghouse employees were able to grow within their jobs. Harold Frazier started at the Forest Hills plant in 1956 as a janitor. He used his 38 years in the reserves to further his expertise and certifications in various aspects of nuclear reactor testing and safety before retiring in 1987. Frazier (left) and former coworker Ray Krevosh are pictured at a 1999 Westinghouse reunion at the Sub Alpine club in Turtle Creek.

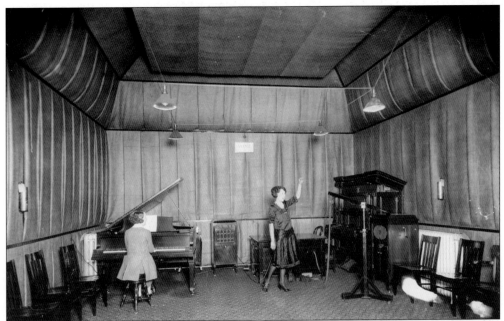

The U.S. Signal Corps used radio during World War I, with assistance from Frank Conrad, a Westinghouse engineer. Conrad used his expertise to further an idea of Dr. H. P. Davis, vice president of engineering and manufacturing. Radio, Davis thought, could be used for mass public communication, not just confidential military work. Westinghouse had the world's first commercial licensed station, KDKA, on the roof of the K Building in the East Pittsburgh plant. The first broadcast on November 2, 1920, was the Warren G. Harding/James M. Cox presidential returns. Among the other programming was music. Lenox Avenue resident Elsie Cook is shown in the photograph above as she sings live on the air. Since the K Building was in a valley, clarity and distance of broadcast were limited. The photograph below shows the Forest Hills facility KDKA moved to in 1923. The higher, more level lot off Greensburg Pike greatly improved KDKA's power.

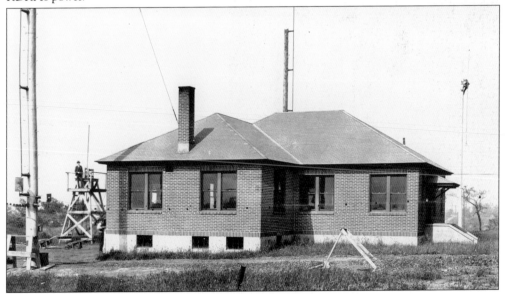

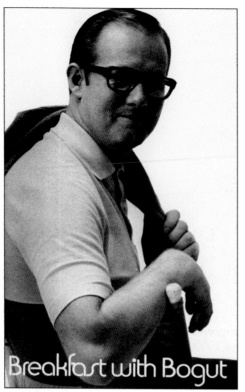

Breakfast with Bogut

From April 27 through May 1, 1970, KDKA radio's Jack Bogut hosted "Breakfast with Bogut" in the Tea Room at Joseph Horne Department Store in downtown Pittsburgh. Horne's had sold Westinghouse radios before the 1920 broadcast. A parade of broadcasting and political celebrities helped Bogut in this joint celebration of Horne's 121st anniversary and KDKA radio's 50th anniversary as the world's first regularly programmed radio station.

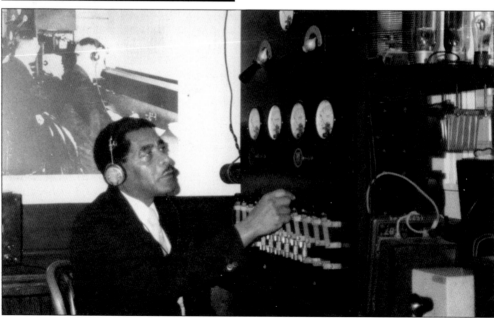

In 1990, Westinghouse celebrated the 70th anniversary of KDKA radio. Using a photograph of the original broadcasters, including announcer Leo Rosenberg, as a backdrop, the Pittsburgh Antique Radio Society displayed a re-creation of the original KDKA East Pittsburgh broadcast set in the Westinghouse headquarters building lobby in downtown Pittsburgh. Harold Frazier, longtime Westinghouse employee, sits at the controls of the re-created set.

Four

SCHOOL DAYS

Before Forest Hills' 1919 incorporation, the area only had one school; the one-room Duquesne School stood near the corner of Glasgow and Braddock Roads in the Mucklerat neighborhood. More people meant more schools. The Wilkins Township School Board approved the first new school for what would become Forest Hills in the early 1900s. The Bryn Mawr school (Woodside Elementary School) was built between 1913 and 1914. After 1919, the new Forest Hills School Board, with representatives of each neighborhood, saw the need to build more schools. Atlantic Avenue School, near the Westinghouse Plan, opened in 1921. Hawthorne Elementary, in Edgewood Acres, came along in 1922. The Parent-Teacher Association (PTA) soon followed. Leather-bound, handwritten notes detail the first meeting of the Forest Hills School District PTA on November 20, 1923. Professor Harvey called the meeting to order, and T. S. Taylor was elected president.

To meet the growing needs of the community, all three schools underwent numerous face-lifts and additions. After a fire damaged the junior high classrooms at Atlantic Avenue School in the late 1940s, the Forest Hills School Board approved the purchase of the Central Sites area (later known as the Parkway Heights neighborhood) and built Forest Hills Junior High School.

The 1962 opening of Churchill Area High School on Greensburg Pike meant that Forest Hills students no longer had to attend high schools in nearby Wilkinsburg, Turtle Creek, or Edgewood.

The Woodland Hills School District was formed in July 1981 after a controversial court-appointed merger between the Braddock, Churchill, Edgewood, Swissvale, and Turtle Creek School Districts. Churchill Area High School became Woodland Hills High School. By the dawn of the 21st century, all of Forest Hills' elementary schools were gone. The only school building from the original Forest Hills School District, the former Forest Hills Junior High School building on Ridge Avenue, was sold to Trinity Christian School in 1989.

In addition to Trinity Christian School, residents could send their children to local private schools, including St. Maurice Catholic School, which opened in 1953, and Christ Lutheran School, which opened in 1986.

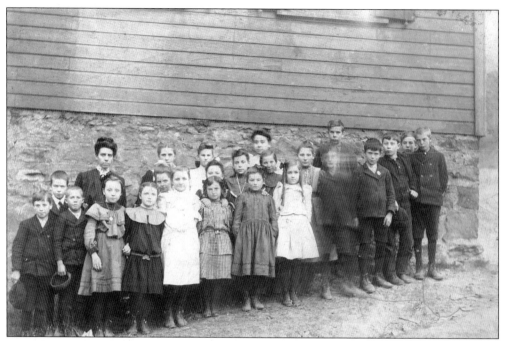

A teacher in the area for over 40 years, Laura Higby is pictured here in two early-20th-century photographs. Higby taught three generations of Forest Hills students, including these unidentified students who attended the Duquesne School. Originally part of the Braddock Township Schools, the Duquesne School was a one-room wooden structure located near the intersection of present-day Braddock and Glasgow Roads. An addition was built in the early 1900s. Parents, concerned that the building was a firetrap because of its wooden structure and potbellied stove, complained to Wilkins Township. Many of the students were children of area coal miners. Those who could afford it sent their children to school in nearby communities. Between 1913 and 1914, the school board built a new school, and in 1917, the Duquesne School was torn down.

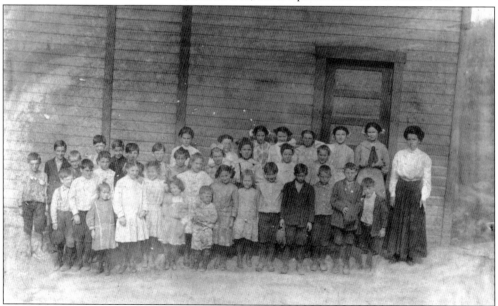

Alice Bright (Stott) and Vera Graham (Pinder) were among the first students who were moved from the Duquesne School to the newly built Bryn Mawr school, which was formally named Woodside Elementary School. Built at the corner of Woodside and Sylvan Roads, Woodside Elementary School was completed by 1914. The school had four classrooms, one of which was used by the American Red Cross. In 1922, two more classrooms and an auditorium were added (pictured at left). Shortly after completion, cracks developed throughout the structure as a result of mine subsidence. Concrete grout was pumped into the holes drilled around the perimeter of the building, which controlled further damage. The class pictured below is from Mrs. Slonaker's first-grade class in 1935–1936. The students in the first row are, from left to right, Rita Wertman, Joan Brown, Joanne Boyer, and Carol Wagner.

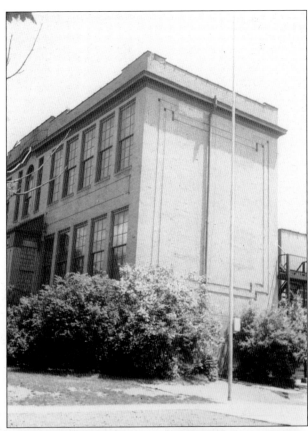

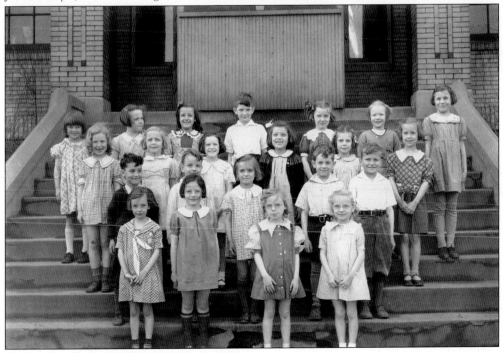

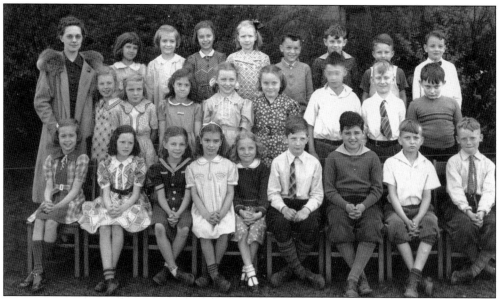

The auditorium at Woodside Elementary was a busy place. In addition to school events, the space was also used for club meetings, including the Boy Scouts, and as a local polling place. During the 1937–1938 school year, Elizabeth Nycum taught this third-grade class. In the back row are, from left to right, Betty Gilson, Evelyn Rittinach, Peggy Richardson, Diane Nicodermus, Roger Weltman, Graham Pinder, Stanley Walton, and Richard Hayford.

FOREST HILLS SCHOOL DISTRICT

DEAR PARENT (or Guardian):—
Following is a checked form giving a report of the work of __*Graham Pinder*__

for the _____*first*_____ report period, 194*0* · 194*1*

REPORT OF STUDIES

Especially good work in:	Average work in:	Subjects needing special attention
Arithmetic		
English – History		
Geog. Reading		
Spelling		

KEEP THE CHART CLEAN

If a trait is unsatisfactory, it is checked. A clean chart means all traits listed apply to this child.

HEALTH	CITIZENSHIP	WORK HABITS
Takes good care of teeth	Days absent *0*	Does not give up easily
Has good vision	Times tardy *0*	Is self-reliant
Has good hearing	Shows self-control	Work carefully done
Has habits of cleanliness	Is reliable	Does not waste time
Has habits of neatness	Works well with others	Doing his best
Has good posture	Is courteous	
Has apparent good health	Takes care of property	
Health report approved	Is obedient	
	Plays fair	

————————————— *Vera Berger* Grade __*6*__
School Nurse Teacher

NOTE TO PARENT—It will not be necessary to return this letter to the school.
FORM REPORT—1ST THRU 6TH GRADES. APPROVED: D. PAUL JONES, SUPV. PRIN.

Here is a sample report card from the Forest Hills School District in 1941. Woodside Elementary sixth-grade students were not graded by what most current students know as the letter grading system. Instead core classes were graded as "especially good work in," "average work in," and "subjects needing special attention." Comments were also made on the student's health, citizenship, and work habits.

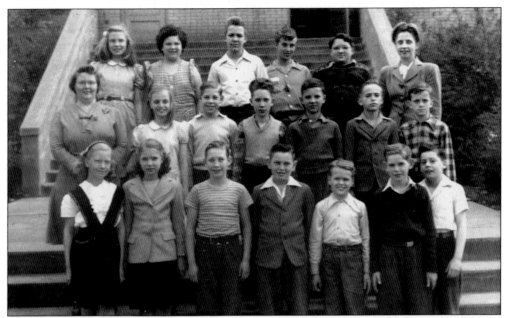

This 1946 photograph from Woodside Elementary School shows Vera Berger's sixth-grade class. Berger is in the third row at the far right. In the first row are, from left to right, Grace Solomon, Carolyn Beswick, Jim McGill, Pat McCoy, Alan Phillips, Bill Brown, and Jim Fresch. A 1946 fire destroyed many classrooms at Atlantic Avenue School, forcing these students to attend junior high school at the Johnston School in Wilkinsburg.

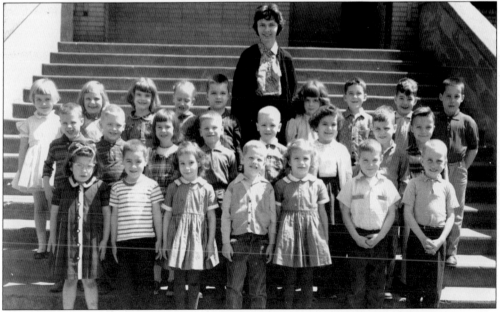

Woodside Elementary School had a second addition built in 1955. The school occupied a three-acre lot, had eight classrooms, and served students in kindergarten through sixth grade. The school's capacity was 240 students. Pictured here is a 1961 kindergarten class. After the school closed, the local Greek community briefly used the building as a Panhellenic center. Later, when the building was torn down, single-family homes were built on the site.

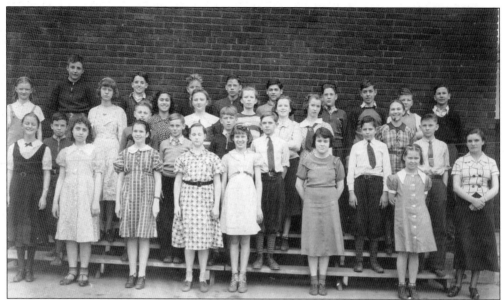

In 1928, Atlantic Avenue School was expanded to include additional classrooms and a combination gymnasium/auditorium. After the expansion, the school served students in grades 1 through 9. While most of the students in the 1936 Atlantic Avenue School photograph are unidentified, some of the students are Lee Frost (second row, second from the left), Raymond Aiello (second row, second from the right), and June Berkinbin (third row, fourth from the left, with large white collar).

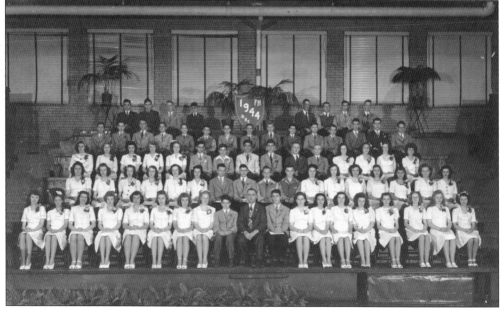

Children attended Forest Hills Junior High School, located at Atlantic Avenue School, until the new junior high was opened in 1949. This ninth-grade class photograph from the class of 1944 was taken in the gymnasium/auditorium on the metal bleachers that covered the far wall, opposite from the stage. Jim McGregor, who later became a local judge, is pictured in the front row, ninth from the left.

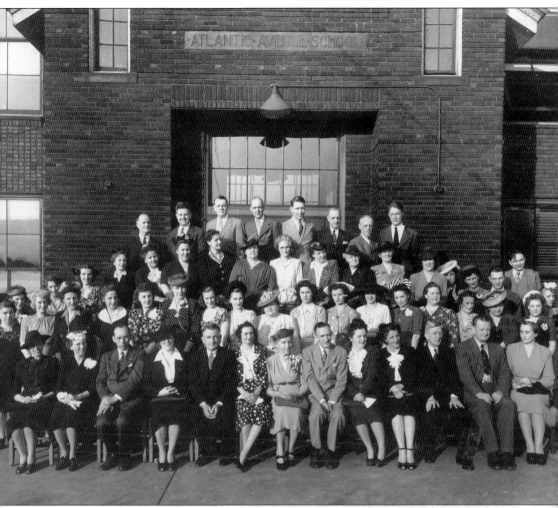

Atlantic Avenue School faculty, school administrators, and spouses gathered for this 1944 photograph taken in front of the original section of the school. Some of those pictured in the front row, from left to right, are Stella Nead, Nelda Shaffer, unidentified, unidentified, Gene Mellott, Mrs. Gene Mellott, Laura Higby, Dale Roose, Mrs. Dale Roose, unidentified, Dr. Ramaley (assistant superintendent of county schools), Dr. Houk, and Hilda Byerly. Two years after this photograph was taken, fire caused damage costing over $100,000 to repair. Low water pressure prevented the fire from being extinguished, thus worsening the damage. Six fire companies were called to fight the fire and keep the building from being totally destroyed. The fire did spur some progress; plans were escalated to design and build the new junior high school at Central Sites.

Students at the Forest Hills Junior High School were treated to a guest celebrity speaker at their promotion exercises on Monday, May 24, 1948. A. K. "Rosie" Rowswell, radio announcer for the Pittsburgh Pirates, was the featured speaker for the ceremony, which the booklet pictured here details. D. Paul Jones was the supervising principal. George M. Baumgarten, president of the school board, handed out the diplomas.

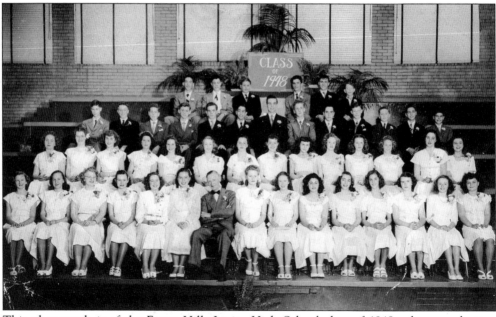

This photograph is of the Forest Hills Junior High School class of 1948, whose graduation program is pictured above. The Atlantic Avenue facility was used as a polling place and was home to various civic and youth organizations, including Scout troops. The first PTA meeting was held here on November 20, 1923. In the 1960s, the PTA hosted an end-of-the-year carnival in the parking lot.

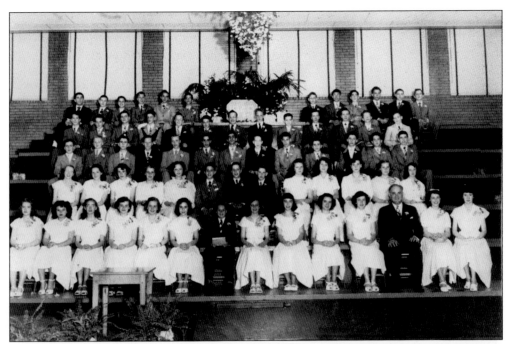

Students from this 1949 Forest Hills Junior High School photograph were the last group to attend both the Johnston School in Wilkinsburg and Forest Hills Junior High. After the fire at Atlantic Avenue School damaged classrooms, students split time between the two schools. Most of the students are unidentified, except for Jack McGregor (fourth row, sixth from the left) and Pat McCoy (top row, second from the left).

By the mid-1950s, the fire damage had been repaired and Atlantic Avenue students enjoyed the use of the combination auditorium, gymnasium, and cafeteria. Pictured in the play *The Wizard of Oz* are, from left to right, Shirley Roth (Wicked Witch), Loretta Puchak (Fairy Princess), and Roz Roth (Glinda, the Good Witch). By the 1960s, the stage was closed off and the space was used as the school's library.

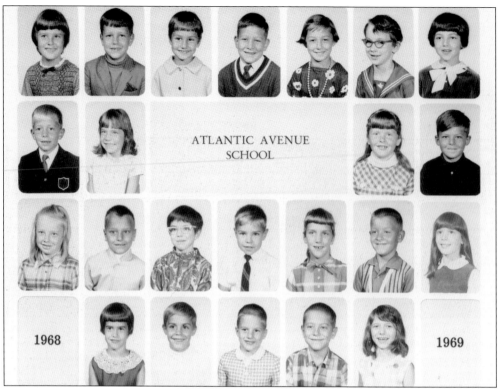

By the early 1960s, Atlantic Avenue had students from kindergarten through sixth grade. The school borders had been reorganized, and students from Edgewood Acres and Parkway Heights were bused to Atlantic Avenue to keep class sizes manageable. Pictured in the top row of Mrs. McAfee's second-grade class are, from left to right, Laura Lipchak, Brian Yost, Kathy Vallino, Tom Quick, Linda Oswalt, Beth Hawkins, and Georgia Spanos.

Two of the school's unique features were the fruit and flowering trees on the grounds and the huge safe in the cloakroom of one of the front classrooms. This group of 1973 Atlantic Avenue graduates held a mini reunion at their 20th Churchill Area High School reunion in 1999. From left to right are Betsy (Langford) Peck, Jody Shapiro, Terry Walton, and Karen (Kerner) Sabol.

Hawthorne Elementary School, located on Hawthorne Road at Cascade Road in Edgewood Acres, was the smallest of the borough's three elementary schools, with seven classrooms. Built in 1922, the school later expanded in 1952. The school sat on 3.2 acres. These unidentified children are pictured playing on the baseball field at the school in the late 1940s or early 1950s.

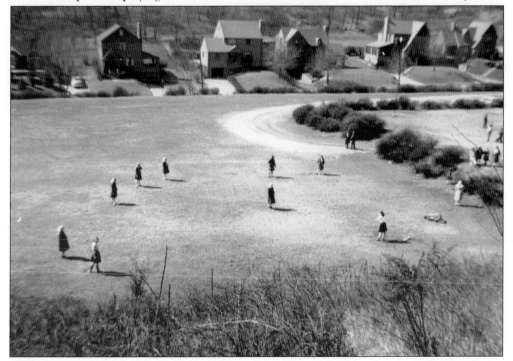

This photograph, taken in the late 1940s or early 1950s, is looking down on the Hawthorne Elementary School large ball field on the left and the upper playground on the right. Cascade Road homes can be seen in the background.

After the addition was built onto Hawthorne Elementary in 1952, the school could hold up to 210 students, grades kindergarten through 6. This photograph, taken of a fifth-grade class in 1967–1968, includes teacher Pauline Dalton, pictured in the second row, far right. Dalton was visually impaired and is pictured here with her guide dog, who accompanied her to class.

Deborah Killen's sixth graders from 1972–1973 at Hawthorne are, from left to right, (top row) Elizabeth Webb, Blanca Correa, Brian Keith, Deborah Killen, Eric Knapp, Ellen Damasio, and Mike Perry; (second two), Sandy Keith, Rick Morgan, Bruce Miller, and Gretchen Watson; (third row) Robert Newton, Patty Wyche, Joyce McConnell, Bill Huhn, Laurie Delserone, Linda Dering, and David Pancerev; (fourth row) Susan Roy, Lucinda Connelly, Robert Bennett, Maribeth Nicholls, Dan Melany, and Mark Lisovich.

Hawthorne Elementary School is pictured in 1987. After the school was torn down, single-family homes were built at the site. As of 2006, Forest Hills does not have an elementary school within the borough. Students in the Woodland Hills School District attend Edgewood, Shaffer, or Wilkins primary schools. Other schools include Dickson Intermediate, Fairless Intermediate, Rankin Intermediate, East Junior High, West Junior High, and Woodland Hills High School.

When the school board opened Forest Hills Junior High School in 1949, debt stretched the small district, still recovering from the Depression and the cost of repairs to Atlantic Avenue School. The school was centrally located on 18 acres on Ridge Avenue near Braddock Road. Students walked or took the Burelli bus to school. John Finfrock, pictured here, was a popular Civil War history teacher in the early 1950s.

Before the auditorium was added to Forest Hills Junior High School in 1965, students performed shows in the combination lunchroom/auditorium. Pictured here are Joan Earhart (left) and Pam Norelli practicing for a school play in the early 1950s. A new addition in 1965 brought the school up to 25 classrooms, a cafeteria, an auditorium, and a music room. The school could hold up to 600 students in grades 7 through 9.

School dances were a popular form of entertainment throughout the nearly 50 years of Forest Hills Junior High School's history. Pictured in the early 1950s planning a hoedown dance are, from left to right, unidentified, Leonard Milatti, Loretta Puchak, Randy Franz, and Tommy Passant.

Open house was always a big event at Forest Hills Junior High. The brochure from the November 12, 1969, event is pictured here. This program was held on the 49th anniversary of American Education Week. The principal at the time was Benjamin R. Robertson, who would often delight parents and students alike with his acrobatics and quick wit. Paul H. Deffenbaugh was the assistant principal.

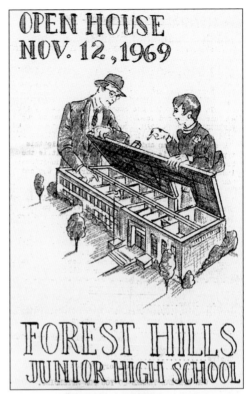

OPEN HOUSE NOV. 12, 1969

FOREST HILLS JUNIOR HIGH SCHOOL

Forest Hillian

FOREST HILLS JUNIOR HIGH FINAL EDITION 1975–1976

also been taking piano at Carnegie Mellon for about five and a half years. In addition to that she plays the violin in our school orchestra and she sings first soprano in the Mixed Chorus. The role of the first milkmaid in the operetta (May 28th and 29th, by the way) will be played by Vilma.

She has been selected for Mixed Chorus at the high school next year. She will sing

Student reporters for the monthly *Forest Hillian* detailed such traditions at Forest Hills Junior High as annual Harrisburg-Gettysburg bus trips, operettas, and Snowball Hop dances. The issue pictured is from May 1976. The last ninth-grade class to graduate from the school was in June 1979. In the 1980 school year, Forest Hills Junior High became a middle school. Eighth- and ninth-grade students went to Wilkins Junior High School.

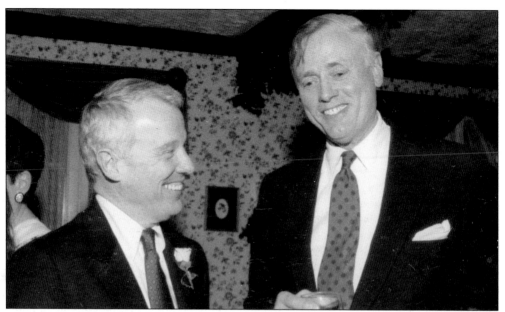

Many students walked several miles to high school in Wilkinsburg. If they could afford the 35¢ pass, they took the 87 Ardmore to and from class. Other students went to high schools in nearby Edgewood or Turtle Creek. Two Wilkinsburg High School graduates and Edgewood Acres natives, Jack McGregor (left) and Charley West, are pictured in this 1973 photograph. West was the high school basketball captain in 1951–1952.

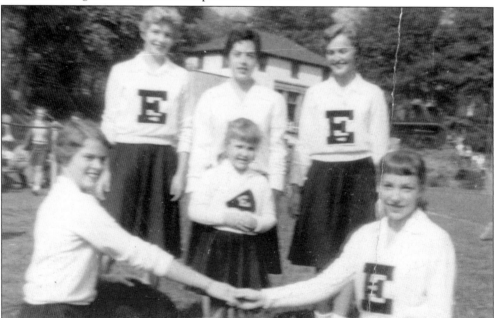

Some Forest Hills residents went to high school in Edgewood, at what is now the Edgewood Elementary School on Maple Avenue. Students from the borough would walk or ride one of Ralph Burelli's buses to school. Pictured cheering at an Edgewood football game are, from left to right, (first row) Sue Rengel, Jeannine Stoher, and Janny Stoher; (second row) Sue Conley, Shirley Roth, and Cynthia Hawkins.

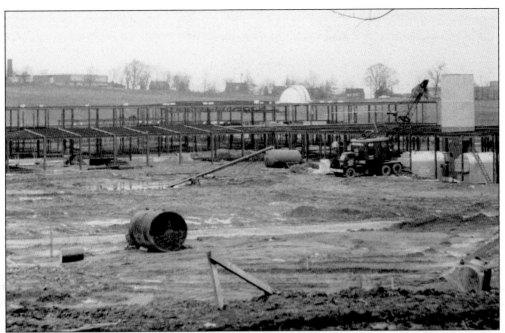

Between 1960 and 1962, Wilkins Township and the boroughs of Forest Hills, Churchill, and Chalfant joined to form the Churchill Area School District. The communities had numerous elementary schools and junior high schools but no senior high school. When Churchill Area High School (now Woodland Hills High School) opened in 1962, it was a welcome addition to the area. The school was considered state-of-the-art, with its solarium-style library, an indoor swimming pool, large gymnasium, cafeteria, auditorium, and observatory. The first graduating class from the new school was in 1965. These two photographs were taken during construction. The photograph above is looking up toward Greensburg Pike. Churchill Elementary School is at the top left. The photograph below is of the outside of the library.

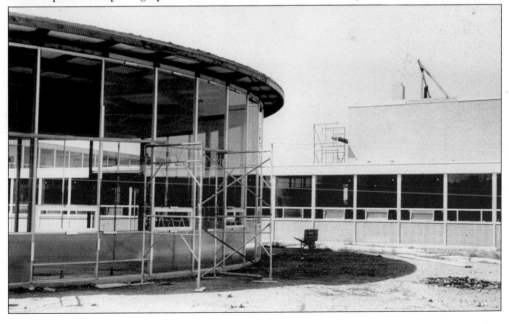

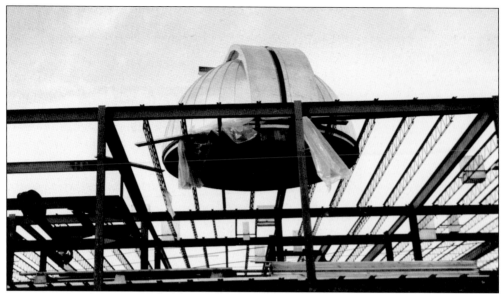

The high school is the centerpiece of the Woodland Hills School District. The creation of the district made national news in 1981 when Judge Gerald Weber ordered the merger of the Braddock, Churchill, Edgewood, Swissvale, and Turtle Creek School Districts. The merger was completed as a phase-in program; the first graduates from Woodland Hills High School were the class of 1988. Despite the controversial start, Woodland Hills students have had many successes, including winning best musical at the Gene Kelly Awards in 1991 for *Guys and Dolls*. The Wolverine football team has won three Western Pennsylvania Interscholastic Athletic League and four conference championships. The team made its second trip to the state championships in 2002. The district celebrated the start of its 25th year on August 28, 2006. The two 1962 construction photographs are of the observatory (above) and swimming pool (below).

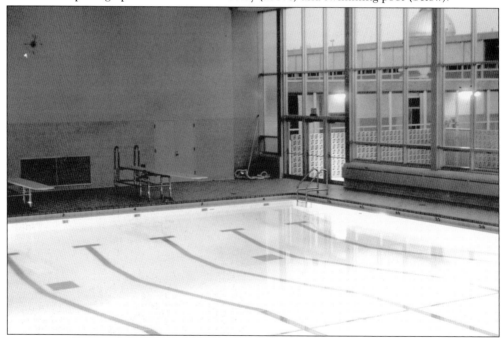

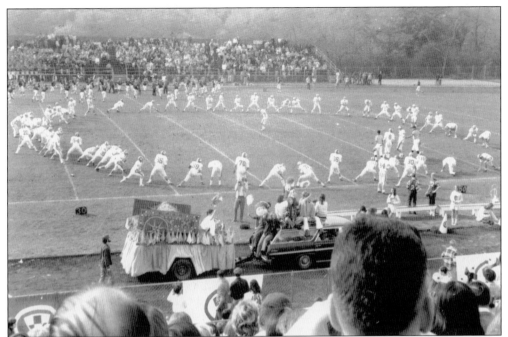

Pictured is Churchill Area High School's 1970 homecoming. Hundreds of boxes of tissue, miles of wire, and hours of laughter went into building the floats. The parade would span Greensburg Pike, and the floats were lined up on the high school field for judging. The Churchill Area High School band is in the background. The car in the foreground is carrying an unidentified homecoming queen nominee.

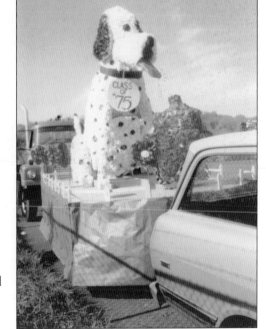

Picking the homecoming theme was an annual challenge at Churchill Area High School. Led by class president Dave Winter, the 1973–1974 class chose "Eras in Time" and the band/orchestra won the best float award for its Mississippi riverboat float. Pictured here is the class of 1975 float.

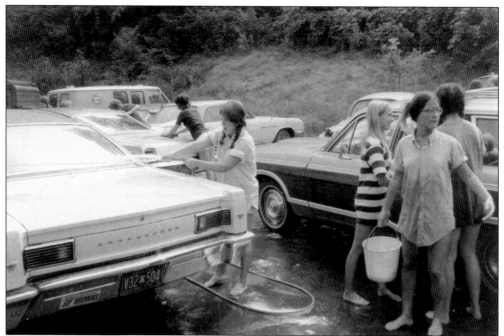

Car washes at Katchmar's Gulf station on Ardmore Boulevard at Bryn Mawr and later at J. P. Tyke's Gulf station on Greensburg Pike helped raise money for numerous Churchill Area High School clubs, such as American Field Service, Pep Club, and French Club. This 1971 car wash was held at Katchmar's. Facing the camera are, from left to right, Linda Martin, Carolyn Orr, and Kathy Evans.

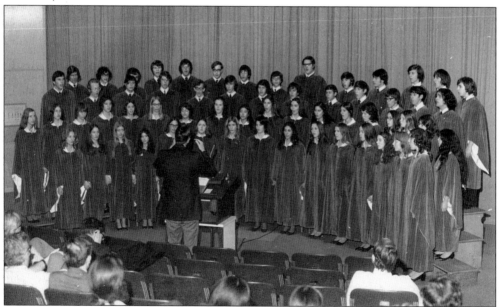

Churchill Area High School had one of the most highly regarded music departments in the area, and the Acappella Choir featured the best of the best voices in the school. Jerry Shannon directed the 1973 choir, pictured here in its familiar blue velvet robes with white collars. Shannon was an integral part of the high school's music department for a number of years.

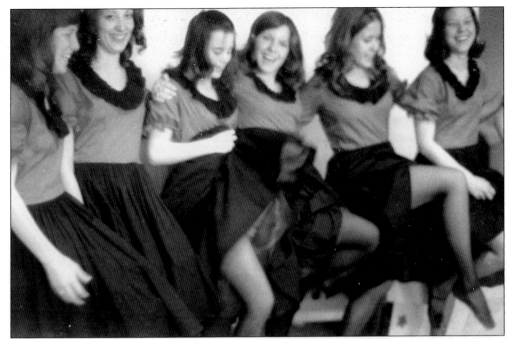

The annual French Café was a spring highlight at Churchill Area High School. A fund-raiser sponsored by the French Club, the event created a French bistro atmosphere featuring music, food, and entertainment. Pictured in 1973 are the cancan dancers. Gretchen Gray is fourth from the left, and Jan Turkovich is at the far right. The others are not identified.

Dr. C. Paul Clark was the superintendent of schools in 1973, when this graduation picture was taken. One highlight of the class of 1973 was its musical performance of *Bye Bye Birdie*. Pictured on her graduation day in 1973 is Gail Evans.

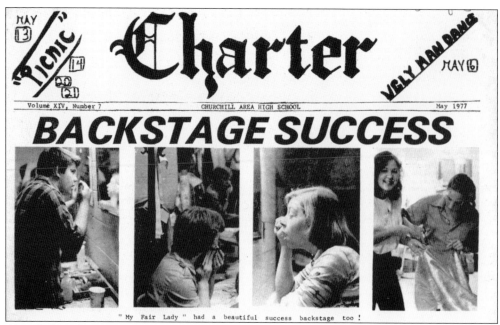

MAY 13 Picnic 14 20 21

Charter

UGLY MAN DANCE MAY 6

Volume XIV, Number 7 CHURCHILL AREA HIGH SCHOOL May 1977

BACKSTAGE SUCCESS

" My Fair Lady " had a beautiful success backstage too !

Churchill students looked to the *Charter* newspaper for news. Published by the Journalism I and II students, the May 1977 newspaper pictured here was edited by Mary Ellen Cannon and Steve Holtzman. Adrienne Miller was the sponsoring teacher. Preparation for the musical *My Fair Lady* was the lead story. For the daily scoop, the *Mini Charter* was the hot item, expanding that year from one page to two.

Churchill's colors were red and white, and the Charger, a knight on a white horse, with CAHS on his shield, was the mascot. The band's motto was Pride Through Tradition, and Gerald M. Rauso was the director. The Sparkling Chargettes and Colorguard brightened the field. Jon Tallet (left) and Tom Steele are pictured in 1980 with the American Field Service float at the homecoming parade.

74

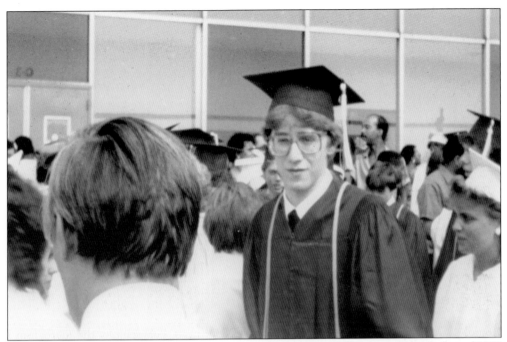

As the first phase in the Woodland Hills merger, the Churchill Area High School class of 1983 included students who had attended seventh through ninth grades at Forest Hills, Wilkins, or Braddock Junior High/Middle Schools before going to Churchill. In 1986, the math and special arts wings were built as one of the first steps to the completion of the merger. Howard Shapiro is pictured at his 1983 Churchill graduation.

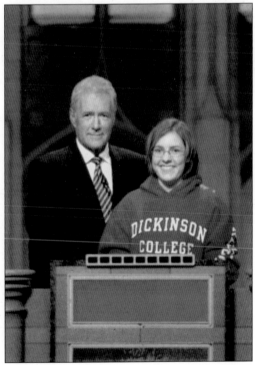

Participating in television game shows was nothing new for local students. In the 1970s, students participated in WTAE-TV's *Junior High Quiz*, hosted by Ricki Wertz. Woodland Hills alumnus Rachel McCool (left) took the national Jeopardy! Challenge when she was on the show's college championship in Pittsburgh in October 2004. Then a student at Dickinson College, McCool is pictured with the show's host, Alex Trebek. (Courtesy of Jeopardy! Productions)

St. Maurice Catholic School opened in Forest Hills in 1953. Lay teachers, along with the Pittsburgh Sisters of Mercy, staff the school, which includes grades kindergarten through 8. Numerous activities, including boys' and girls' basketball, forensics, the Pennsylvania Junior Academy of Science, and the Pittsburgh Science Fair challenge students. This photograph was taken in 1969. Among the recent modernizations is the addition of a gymnasium.

Christ Lutheran School started its day school in 1983, two years after successfully launching a preschool program. Serving students in grades kindergarten through 8, the school offers both academic and religious training to area students. Among the activities that students can participate in are math competitions, science fairs, and track-and-field competitions. This photograph was taken at the school's groundbreaking ceremony in 1989.

Five

NURTURING THE SPIRIT

The faiths represented and celebrated by the people of Forest Hills live in the individual homes of the residents, as well as in the many houses of worship found in the borough. And the faiths, strong as they are, are not insular. Jewish children go with their parents to the annual summer festival at the Roman Catholic St. Maurice Parish. The Greek food festival, held every August by Ypapanti, the Greek Orthodox church in nearby East Pittsburgh, is a delicious tradition for people of all faiths. The Hand Bell Choir concert in the summer of 2006 at Forest Hills Presbyterian Church entertained and touched more than just Presbyterians.

The spirit of differing faiths complementing and understanding one another was perfectly illustrated with Religious Heritage Day, a part of the borough's weeklong golden jubilee celebration in 1969. Area religious leaders hosted the evening of June 29, 1969, at Churchill Area High School. E. Lincoln Van Sickel was chairman. Ushers volunteered from all the local houses of worship. Joseph Casilli from St. Maurice Parish played the organ, which was provided by Longdon Piano Company of Wilkinsburg. Perhaps the most demonstrative aspect of this evening of cooperation was the combined choir, comprised of area residents. The music, as the program notes state, was selected to "inspire spiritual growth in the community." Among the songs were "Psalm 150" and "Lauda Anima."

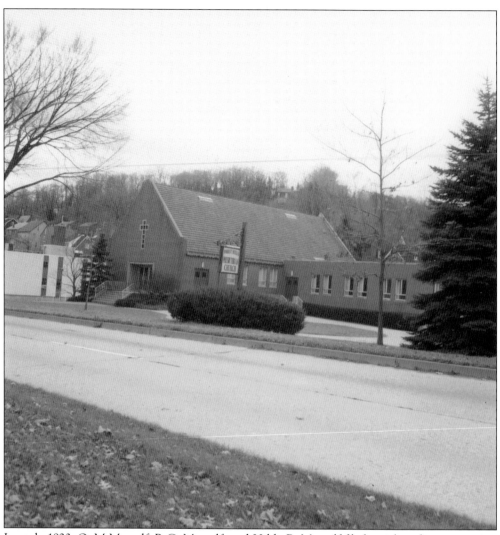

In early 1923, O. M Metcalf, P. C. Metcalf, and Hilda B. Metcalf filed articles of incorporation for Forest Hills Presbyterian Church. The original location of the church was at 501 Atlantic Avenue, next to Atlantic Avenue School. Among the original members listed on the corporate application was Al Koch. As the congregation grew, a new house of worship was needed. Groundbreaking for the church's new home on Ardmore Boulevard, the *Forest Hills News* reported, was in 1955. Ian Ruffing of the church building committee estimated the cost at $150,000. The money came from personal pledges, United States savings bonds, and other sources. The new building, pictured here in 1983, was opened in 1957. The old building on Atlantic Avenue would later serve as home to the Russian Orthodox Church.

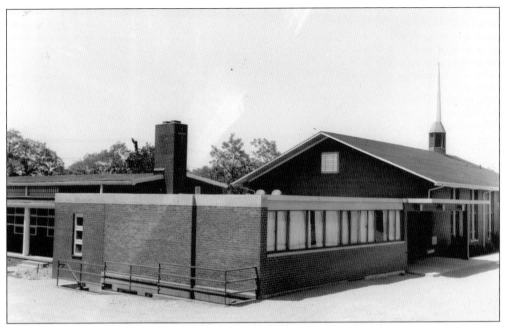

The history of Hope Lutheran Church at Braddock Road and Ridge Avenue goes back more than half a century to June 11, 1950. Rev. Frederick Steuber, with Alice Treser on piano, held the first service at the Women's Club of Forest Hills clubhouse. The church building, pictured here, was dedicated in July 1952. The new sanctuary was dedicated in 1968.

Hope Lutheran Church has long been a source of outreach programs in the area. Whether nurturing congregants' spirits or helping to feed the underprivileged, the church and its ideals have thrived in large part due to the dedication of the people. From left to right are original founding members Agnes and John Savage, Betty Smoose, and Fred and Dorothy Dase.

Hope Lutheran members knew from the outset how to have fun as a community and as a family. A look at their early chronology shows parties and holiday celebrations as well as logistical milestones. October 28, 1950, was the date of the first Halloween party, hosted by the Treser family. The trend continues today, as the unidentified women here prepare for the church's annual Oktoberfest and Blessing of Animals.

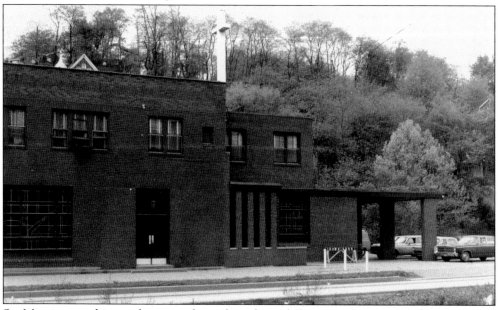

St. Maurice parishioners have worshipped at three different Ardmore Boulevard locations. Without a home of their own yet, the first mass was celebrated at the Memory Lane Roller Rink on July 3, 1949. The congregation moved in May 1950 to a building, pictured here, that had previously been a Coca-Cola distribution center and an Oldsmobile dealer. The present location, at Ardmore Boulevard and Filmore Road, was dedicated in 1977.

Lorraine Brucker Full (Matusz) is shown here in the 1960s with her children Bob and Sharon on their way home from St. Maurice on a Sunday morning. As more and more families like Lorraine's came to St. Maurice into the 1970s, a larger house of worship was needed. The growth that spurred the new church opening in 1977 continues today. As of 2006, the church has over 2,000 families.

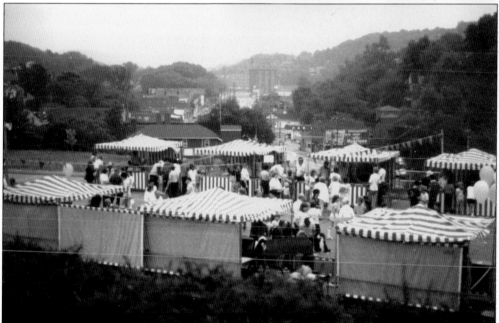

Every June, the St. Maurice Festival, pictured here in the early 1980s, fills the air with smells of hot dogs, burgers, and funnel cake. In addition to the food, the festival features entertainment, games, and often a mini flea market. This annual fund-raiser for the parish attracts people from all across the community.

Although there were no synagogues in Forest Hills, Jewish residents did not have to go far to find one. There were, at one time, two synagogues in Braddock—Ahavath Achim for Russians and the Eleventh Street Congregation for central European Jews. Ahavath Achim is still in operation, but only for a few days a year for the High Holidays. The cemetery for both synagogues is on Sherwood Road.

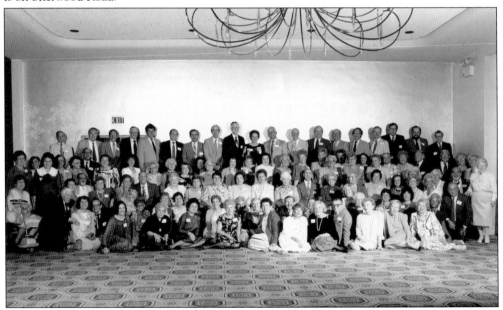

Ruth Roth walked her family on Friday nights to Oheb Zedek synagogue in East Pittsburgh. Marian Neustadt's father, Herman "Harry," gave bar mitzvah lessons in their Halsey Avenue living room. Oheb Zedek closed in 1952. This reunion photograph was taken at Beth Shalom synagogue in Squirrel Hill in the 1970s. Marian (Hershman) is standing in the third row, 15th from the left (in white shirt), and Ruth and her husband, Sam, are 6th and 5th from the right in the third row.

The region has a strong Greek American community. Ypapanti, the Greek Orthodox church on Electric Avenue in nearby East Pittsburgh, has grown from 83 families in 1915 to become the center of Greek American life in the area. The 90th anniversary book, shown here, celebrates and acknowledges all in the community who have helped the church to thrive.

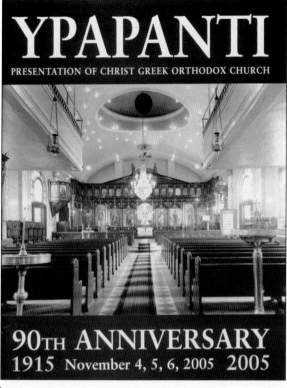

YPAPANTI
PRESENTATION OF CHRIST GREEK ORTHODOX CHURCH

90TH ANNIVERSARY
1915 November 4, 5, 6, 2005 2005

2004
TWENTY-FIRST ANNUAL
GREEK FOOD FESTIVAL

OLYMPIA HALL

PRESENTATION of CHRIST
GREEK ORTHODOX CHURCH

FREE ADMISSION
AUGUST 19, 20, 21, 22
Thursday, Friday, Saturday, Sunday
11:30 AM-10:30 PM Daily
Outdoor Grecian Garden and Banquet Hall

In 1978, Westinghouse sold Ypapanti the lot across the street from its church for $64,000. Olympia Hall was built on the site and opened in 1984. A popular site for wedding receptions and weddings of all faiths, Olympia Hall is also home to Ypapanti's Greek food festival. The menu here is from the 2004 festival. Ypapanti uses this annual tradition as a showcase for Greek culture.

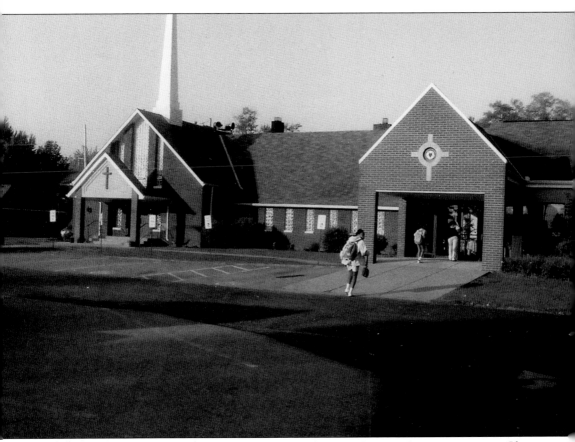

The Ardmore Mission, run by Rev. Oliver E. Graebner on Sumner Avenue, grew into Christ Lutheran Church of Forest Hills in the early 1930s. Now located on Barclay Avenue, it serves children and families in the community. Education is closely tied together with the church. The preschool, day school, and child care programs integrate religious instruction into each child's day. Education does not stop with the children; adult Bible study sessions are available. Fellowship and social activities, such as Christmas concerts and live Nativity displays, are part of how the church reaches out to the Forest Hills community as a whole. Another way Christ Lutheran serves the community is by having a fund-raising recycling drop box in its parking lot. The ability to recycle allows all Forest Hills residents to care for the environment. Christ Lutheran uses the proceeds for its programs.

Six

POLICE, FIRE, AND RESCUE

Local residents have been fortunate to have dedicated fire and police forces since before the borough's incorporation. Forest Hills' fire, police, and, later, ambulance services have evolved since the area was part of Wilkins Township in the early 1900s. The fire department has gone from a single hand-drawn wagon in 1918 with a few dedicated volunteers to six full-size, state-of-the-art fire trucks and over 30 highly trained volunteer firefighters. Residents to this day can set their watches by the Saturday noon fire whistle test and the nightly 9:45 p.m. whistle that signals 15 minutes until curfew.

The original 1919 two-man police force served the borough's 1,500 residents well. As of 2006, the police force included eight officers, two sergeants, and the chief, serving nearly 7,000 residents. Women were sworn into the police force as crossing guards in 1952. The auxiliary police force was formed in 1954. In 2004, Nomos, the borough's first police dog, was sworn into service. He was forced to retire in early 2007 after suffering a painful but non-life-threatening back injury. A portrait of Nomos by local artist Nina Stahlberg hangs in the borough office.

A formal ambulance service did not exist in the borough until 1971 when Rescue 8 was formed. In 2002, Rescue 8 merged with Rescue One from neighboring Churchill to form Woodland Hills EMS, which serves Forest Hills, Churchill, Wilkins, and Chalfant and supports the surrounding communities as needed.

The police, firefighters, and rescue personnel do not serve the borough's residents in just the bad times. The firefighters and the borough fire vehicles participate in local parades, including the Woodland Hills High School annual homecoming parade. Local police officers and paramedics often speak at the local schools.

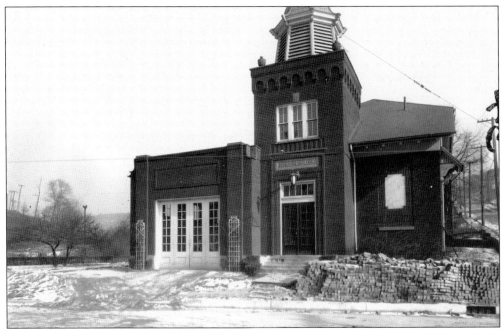

The municipal building, shown shortly after opening in 1922, gave the police and fire departments a new home. The fire wagon was previously housed in a local resident's garage. The fire whistle was located in the cupola on top of the building until the mid-1960s, when the system was redesigned and the cupola removed. The alert whistle was moved to higher ground so that the sound could better carry.

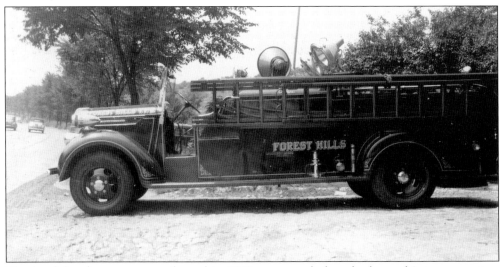

The local fire department was formed in 1918, one year before the borough's incorporation, when a group of men in the Westinghouse Plan used a hand-drawn wagon to fight fires. As the borough grew in population and commerce, fire-protection needs expanded. The council purchased this 1939 International fire truck, a 450-gallon pumper that served the borough for over 30 years.

The fire department received its charter in 1935. The department's officers were Walter Keyser, president; Harold Kirk, vice president; Joe Gera, secretary; and Albert Korhnak, treasurer. This photograph was taken at a late-1930s firefighters banquet. The female singers are not identified. The Forest Hills firefighters are, from left to right, (first row) John Cortazzo and Tom Bricker; (second row) Bob Bash, Anthony Brucker, Chuck Lavish, and unidentified.

Wilbur Wright was the borough's fire chief for over 30 years until his promotion to fire marshal in 1968. Ray Heller Sr. assumed the role of chief in 1968 and has served the borough for over 40 years. The department facilities underwent renovations in 1969 and in 1997. The hall, located behind the municipal building, is shown here in 1969. The 1997 expansion nearly doubled the fire department's space.

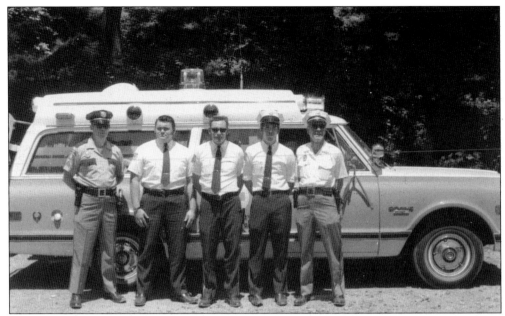

Forest Hills is the home for the Eastern Borough's Fire Fighter Association and the Red Team of the Allegheny County Hazardous Materials Unit. The association formed in 1947 to better pool area resources. Part of the East Borough Response Organization, the Red Team is celebrating its 20th anniversary in 2007. Firefighters in this 1971 photograph are, from left to right, Andy Gass, Dave Nichalos, Mark Nichalos, unidentified, and Bob Kim.

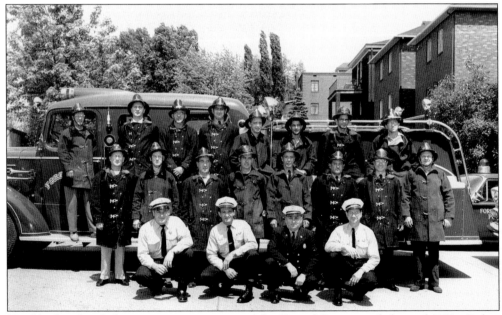

Neighborhood ambulance services were rare in the United States until the mid-1970s. Before formation of the Rescue 8 ambulance service, family members, police, or firefighters transported Forest Hills and Chalfant residents to local hospitals. In 2002, Rescue 8 merged with Wilkins Township and Churchill Borough's Rescue One, forming the Woodland Hills EMS. This photograph is of unidentified firefighters from the late 1960s or early 1970s.

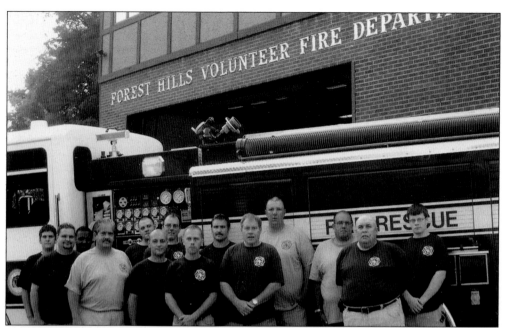

The 2006 firefighters are, from left to right, John Gray, Bob Henkel, Andre Acie, Dick Crowley, Adam McDermott, Philip Brusco, Rich Jackowski, Mark Swinney, Jesse Bridge, Jim Theilacker, Harry Smith, Bud Boalo, Jim Loy, and Thomas Theilacker. Not pictured are Chief Ray Heller Sr., Bob Full, Rick Colella, Larry Heller, Justin Brown, Bill Gorol Sr., Bill Gorol Jr., Wendell Hissrich, Matt Livingstone, Bob Mallick, Bob Millie, Karl Probola, and Bill Smith.

One of the reasons local police, fire, and rescue personnel are so dedicated to protecting and serving Forest Hills is because many of them live in the borough. Their children attend school and play here. Longtime police chief Harry Richard, seated left center in this 1935 photograph, is shown attending a family dinner on Kenmore Avenue.

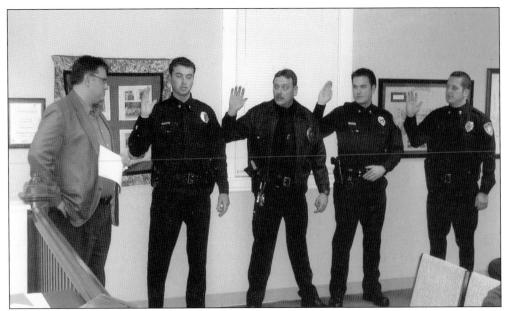

Forest Hills auxiliary police officers have served since 1954. Officers have assisted with traffic control and other duties during events such as civic meetings, school dances, and the annual Community Days celebration and Halloween festivities. Pictured from left to right in November 2005 are Mayor Ray Heller Jr. as he swears in new auxiliary officers Anthony Dudek, Eugene Berezanich, Bob Masters, and Joe Posey.

In 1919, Forest Hills had one police officer, a chief, and a two-room office near Sumner Avenue. In 2006, there were eight officers, two sergeants, and the chief headquartered at the municipal building. Officers support community events such as the annual August National Night Out. They speak at local schools and work with youths at the police camp. Pictured in 2006 is officer Len Mesharchik with grandchildren Genevieve and Xavier.

Seven

GOLDEN JUBILEE

People who were around Forest Hills in 1969 have a variety of ways of remembering how they celebrated the golden jubilee. Someone might look in her recipe box and find what she entered in the Scratch Baking Contest. A personal scrapbook might preserve a ticket stub from the musical *Indians to Atoms*. A commemorative plate can sit on a bookshelf. And a woman might still have the souvenir wooden nickel her father bought for her when she was just eight years old. Perhaps the most common souvenir of Forest Hills' 50th birthday party is the *Golden Jubilee Book*. Here people can leaf through a history lesson. They can look back over the calendar of events and read about any of the festivities held in Main Park or on Ardmore Boulevard. Those who were not born yet or not living here yet can use the *Golden Jubilee Book* as a golden opportunity to see what their parents were doing in 1969 and before.

The jubilee was more than just a 50th birthday party. It was a celebration and an education on borough history. Roger Wentworth, in addition to running Wentworth Insurance and being active in the Rotary, was an area historian. Wentworth is credited with collecting and preserving many irreplaceable documents and images—from 100-year-old photographs to original volunteer fire department meeting minutes from 1935. Some of these documents were used in preparing this publication. In the jubilee book introduction, written by Wentworth along with jubilee general chairman Jack Shepherd, the hope is expressed that residents "cherish and respect the work, the institutions, and the community of their heritage."

1919 **Forest Hills Golden Jubilee** 1969 presents July 1775 **Indians To Atoms** July 1969 A John B. Rogers Production **The Churchill Area High School Stadium** ――――――――――――――――――― **PATRON BOX SEAT ADMISSION** ――――――――――――――――――― Good only on Friday, July 4, 1969 8:00 p.m. BOX **PRICE: $5.00** Tax Exempt **C-8** No Cash Refund	**1969—RAIN CHECK** **Friday, July 4, 1969** **PATRON SEAT ADM.** In the event weather conditions prevent staging less than sixty minutes of the performance, this check may be exchanged only for admittance ticket in same section for any one other scheduled performance. **NO CASH REFUND** **BOX**

Indians to Atoms, a musical telling of the Forest Hills story, was held at Churchill Area High School on several nights the week of the jubilee celebration. John B. Rogers produced the show. The director was Chris Goodyear, who had been hired to oversee the jubilee musical festivities.

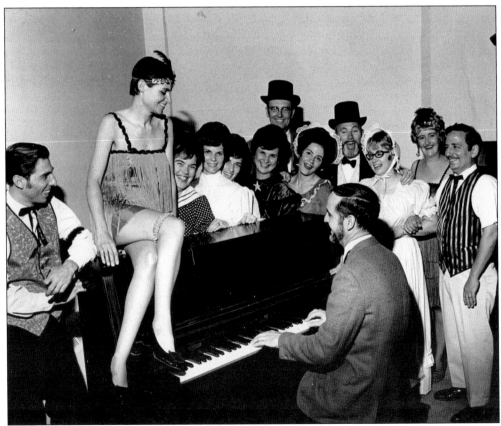

Indians to Atoms spanned several time periods and a variety of themes. The unidentified performers here are just a handful of the local men, women, and children who danced and sang through the musical history lesson on Native Americans, the Gay Nineties, and patriotism, which featured the George M. Cohan classic "Over There."

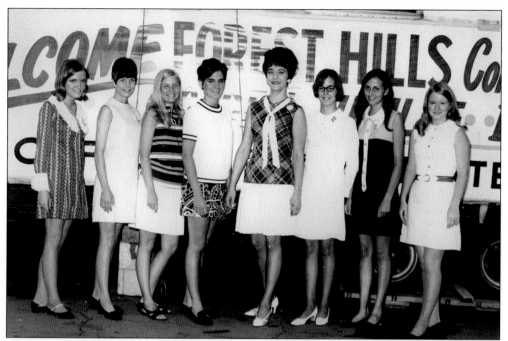

If they wanted the joy of becoming queen, the 25 contestants for Jubilee Queen had to sell tickets for the *Indians to Atoms* production in order to accumulate votes. The ride on a float, the *Jubilee Newsletter* reported, was not the only prize. The top award was a week in the Bahamas. Pictured here are the finalists. Jubilee Queen Nancy Fetterman is at the far left.

Nancy Fetterman and Pam Shaler entered the Jubilee Queen contest for fun, to help support the borough by selling tickets, and to support Nancy's mother, Virginia, who was active on jubilee committees. Nancy sold the most *Indians to Atoms* tickets, so she knew before the ceremony that she had won. She is shown on the queen's float, enjoying the festivities despite a rain-shortened parade.

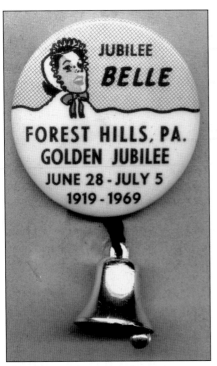

Mayor Richard E. Wise issued a proclamation that "in memory of pioneer great grandmothers of yore, any and all members of the female sex . . . shall refrain from appearing in public . . . while wearing Lipstick, Rouge, Eye shadow, etc.," unless they joined the Jubilee Belles. Wearing a belle pin, pictured here, allowed women to wear any "feminine blandishments."

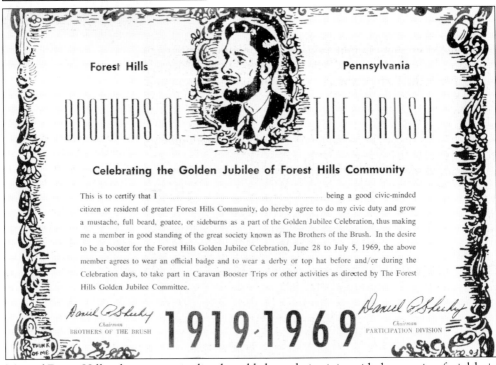

Men of Forest Hills who were so inclined could show their civic pride by growing facial hair. The participants had to wear an official badge along with a derby or top hat in order to be a "member in good standing of the great society known as The Brothers of the Brush." For shaving privileges, men could join the Smoothies Club, as long as they had no "facial foliage."

Good-natured justice was the fate for people not playing along with the jubilee spirit. Citizens received subpoenas for such offenses as having a beard without wearing a Brothers of the Brush button. Punishments included fines, restraint, and/or scorn and ridicule. All this was voluntary, although those not answering the solemn reckoning of "His Royal Majesty, the Right Honorable Judge of the Kangaroo Kourt" risked being branded an "Old Fuddy Duddy."

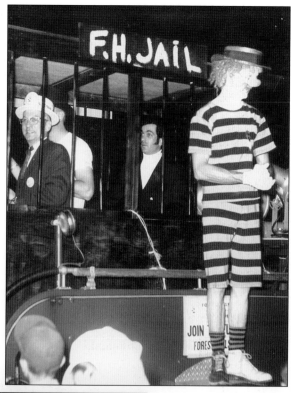

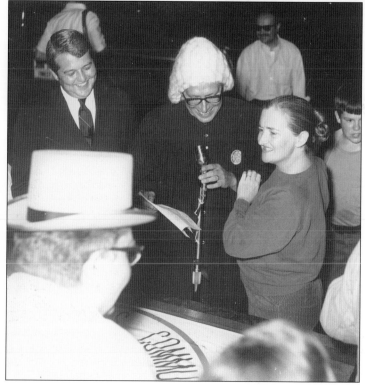

Judge David Fawcett Jr. weighs the scales of justice as resident Kitty Robinson (right) pleads her case before the Kangaroo Kourt. Robinson's offense is not known, but some others are; Mayor Richard E. Wise was found guilty of "inappropriate sideburns," and jubilee general chairman Jack Shepherd was guilty of "trying to appear clean shaven." Robinson's sentence was being dunked in a tub of cold water.

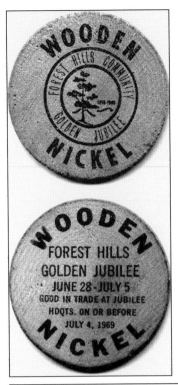

There are numerous jubilee souvenirs people might still have. Pins for the Jubilee Belles or the Brothers of the Brush are a few. And these wooden nickels, shown here both heads and tails, were fun souvenirs for parents to get for their children during visits to the festivities.

Forest Hills Community Golden Jubilee, Inc.

A NON-PROFIT CORPORATION

This certifies that _____ A. Shapiro _____ is the owner of _____ one _____ shares of the SOUVENIR STOCK of the FOREST HILLS COMMUNITY GOLDEN JUBILEE, INC. a Pennsylvania Non-Profit Corporation.

HELD AS EVIDENCE OF PARTICIPATION IN THE FIFTIETH ANNIVERSARY OF THE FOUNDING OF THE BOROUGH OF FOREST HILLS, COUNTY OF ALLEGHENY AND COMMONWEALTH OF PENNSYLVANIA

This certificate is redeemable pro rata out of funds on hand as of August 20, 1969 by the record owner thereof at no more than the face value of one dollar per share, if and when presented to the Treasurer at the Forest Hills Municipal Building during business hours from September 10 through September 30, 1969.

Thereafter this certificate shall not be redeemable but if held, it will be evidence that the holder or his assignor made a contribution of one dollar per share towards the fiftieth anniversary celebration of the founding of Forest Hills Borough.

IN WITNESS WHEREOF, the said Corporation has caused this Certificate to be signed by its duly authorized officer and its Corporate Seal to be hereunto affixed this_____ 6th _____ day of_____ February _____ A.D. 19 69

Richard E. Wise

RICHARD E. WISE, President

Another way for people to celebrate was to own a piece of the jubilee. This certificate shows that Arnold Shapiro bought one share of souvenir stock for $1. Shareholders had the option of redeeming the certificates to get their dollar back following the festivities. But those keeping the certificates as souvenirs were able to show that they contributed to the jubilee celebration.

Eight

FACES, PLACES, TRADITIONS, AND CIVIC PRIDE

Forest Hills residents have never had to travel far to shop, bank, get a haircut, enjoy a meal in a restaurant, watch movies, play outside in parks, or make a difference in their community. Faces, places, traditions, and civic pride are what make the borough the special place it is.

Over the years, people shopped for fruit at Spinelli's or groceries at small markets like Dicoskey's Triangle Market or Krek's Market. Larger chain grocers became popular, and A&P, Giant Eagle, Thoroughfare, Foodland, and Shop 'n Save all had their turn here. The weekly farmers' market, run by the Late Bloomers Club since 2004 to benefit local causes, provides a venue for local farmers and other merchants to sell their goods.

Residents bowled at Forest Hills Auditorium and in the winter ice-skated at Forest Hills Park. Five generations roller-skated at Ardmore Roller Palace (formerly Memory Lane), eight decades of Bryn Mawr residents have celebrated the harvest every September with a corn roast. Dennis' Restaurant (later renamed Drew's) is still popular, and residents miss Sweet Williams, Village Dairy, and the Plaza Restaurant.

With several parks to choose from, residents did not have to go far to play on swings, toss a baseball, or just enjoy a picnic. In the 1960s and early 1970s, families would pack up the kids and watch the latest movies at the Ardmore Drive-In Theatre. Clubs have always been an important way for people to socialize and to help make the borough a better place. Throughout the years, residents belonged to one of two women's clubs, one of two mothers' clubs, one of three mothers' leagues, a men's club, a golf club, and other civic organizations, including AARP, Kiwanis, Lions, and Rotary Clubs. Many of the groups are still active. Children belonged to Camp Fire Girls, International Order of the Rainbow for Girls, Cub Scout packs, and Brownie, Boy, and Girl Scout troops.

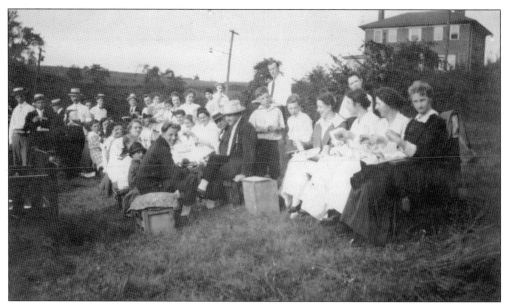

Those who want a sunny day for their outdoor event can take note of the annual Bryn Mawr Community Corn Roast. Held the Saturday after Labor Day since 1916, the event has been rained upon less than a handful of times. The Bryn Mawr Men's Club started the community corn roast. The women's club took over the tradition for a number of years, and later the residents hosted the event. Early locations were backyards. Later the roast moved to Woodside Elementary School's field, and it now is held, block party–style, on Sylvan Road. These two pictures are from the 1917 corn roast, when admission was $1. In 2006, admission was up to $5 a person. The menu at the event is usually corn on the cob, ham barbecue, hot dogs, lemonade, coffee, and ice cream.

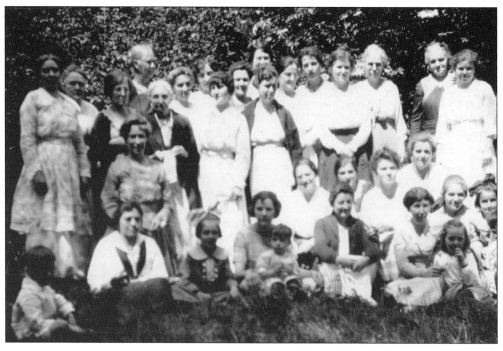

When Forest Hills started the Civilian Defense Council in 1942, over 300 residents joined. Committee members are, from left to right, R. N. Cambridge, John Logan Jr., Frank Kelley, Fred Hastings (chairman), and Edward Hawkens. Not shown are Dr. F. V. Longphre, Robert Critchlow, L. C. Whitney, Walter Keyser, Charles Lavish, Thomas Passant, Frank Kovalovsky, and Edward Lamberger.

Former Forest Hills educator and assistant supervising principal Mary Louise Milligan Rasmuson is pictured in the late 1950s. She served the district from 1932 to 1942. Rasmuson joined the army in 1942, retiring as a colonel in 1962 and moving to Anchorage, Alaska. As of 2006, she is active in the Rasmuson Foundation, named for her late father-in-law, E. A., promoting a better life for Alaskans.

Just about everyone in the borough did his or her part during World War II. Victory gardens were abundant, as residents worked to cope with rationing and the fear of the unknown. One of the largest gardens in the area was one located just above Ardmore Boulevard, at what is now Drew's Restaurant. Shirley Roth is pictured in 1944 at her family's Sumner Avenue victory garden.

During World War II, Forest Hills residents were appointed air raid wardens, held scrap drives, purchased war savings stamps and bonds, and volunteered for the Red Cross. The patriotism did not stop when the war ended. The Forest Hills Woman's Club and Rotary joined forces in 1958 to sponsor blood drives to benefit the local blood bank. Edward Haldeman was the chairman of the program. Dorothy Patterson was the vice chairman.

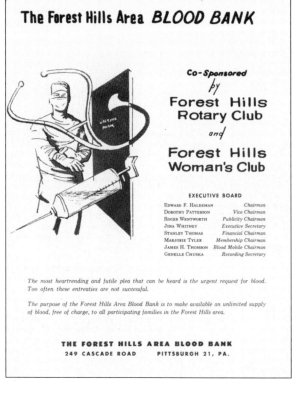

The Forest Hills Area BLOOD BANK

Co-Sponsored
by
Forest Hills
Rotary Club
and
Forest Hills
Woman's Club

EXECUTIVE BOARD

EDWARD F. HALDEMAN — Chairman
DOROTHY PATTERSON — Vice Chairman
ROGER WENTWORTH — Publicity Chairman
JINA WHITNEY — Executive Secretary
STANLEY THOMAS — Financial Chairman
MARJORIE TYLER — Membership Chairman
JAMES H. THOMSON — Blood Mobile Chairman
GENELLE CHUSKA — Recording Secretary

The most heartrending and futile plea that can be heard is the urgent request for blood. Too often these entreaties are not successful.

The purpose of the Forest Hills Area Blood Bank is to make available an unlimited supply of blood, free of charge, to all participating families in the Forest Hills area.

THE FOREST HILLS AREA BLOOD BANK
249 CASCADE ROAD PITTSBURGH 21, PA.

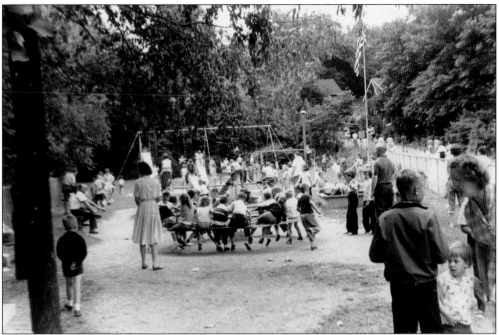

Forest Hills' Main Park, which was purchased by the borough in 1934, is located at the corner of Ardmore Boulevard and Braddock Road. In addition to hosting youth sporting events, the park has been home to the annual Community Days Fourth of July celebration since 1938. The Forest Hills Civic Association has coordinated the event since 1948, with the help of volunteers from almost every civic, social, and Scouting organization in the borough. Activities throughout the years have included raffles, a watermelon-eating contest, grab bags for the children, a water balloon toss, and amusement rides. These photographs are from the 1961 celebration. The photograph above shows families enjoying the park equipment. The photograph below shows a group of unidentified participants competing in the balloon toss.

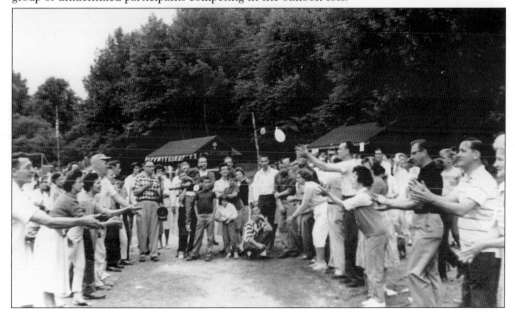

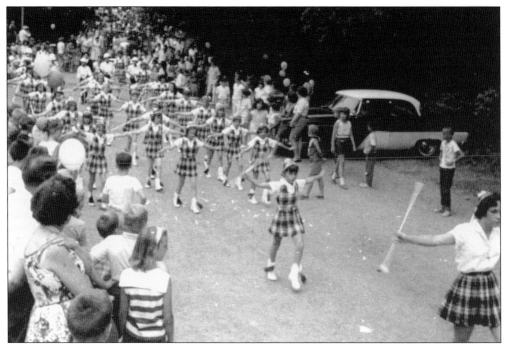

This photograph from a Community Days celebration in the mid-1960s shows the Forest Hills Rangerettes marching into the park from the Braddock Road entrance. The Rangerettes were a junior baton and drum corps that was organized in 1964 and featured a color guard, baton twirlers, and drum section. Most are unidentified, but Gretchen Gray is second in the parade line.

Main Park has had several face-lifts, most recently in 2003–2004, when the borough installed new playground equipment. A toddler area was added, and the trails were refurbished. The Community Days celebration has also kept up with the times, including the recent addition of a simulated rock climbing wall. This unidentified child is pictured at the 2006 event.

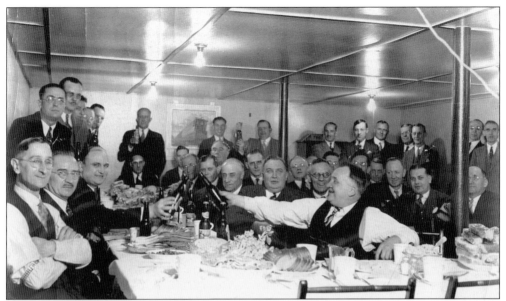

Golf was a big part of the social life of Forest Hills men. This photograph shows members of the Formas Club, sometime in the late 1920s or early 1930s, having refreshments. Members of the club used a golf course just above the municipal building, off Atlantic Avenue. Most pictured here are unidentified. Al Koch is sitting at the bottom left corner, and Hershel Haldeman is standing sixth from the right.

The Bryn Mawr Men's Club was, according to the *Golden Jubilee Book*, the oldest club in the borough. Formed in November 1914, the club met in members' homes. The group sponsored a Cub and Boy Scout troop, organized the neighborhood corn roast, and was active in borough events, including Community Days. Pictured here in 1969 are, from left to right, Russell Fox; Fred Ziesehneim, president; and Frank Garner, secretary/treasurer.

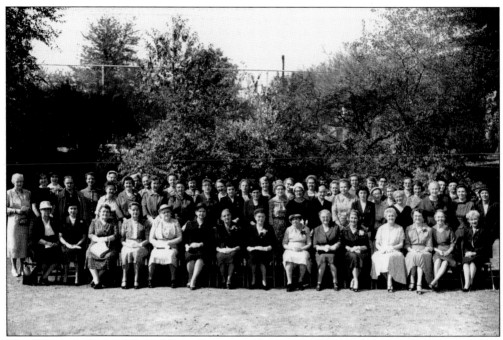

The Woman's Club of Bryn Mawr Farms was formed in 1920 and was still active in 2006. Pictured are the 1960 and 1970 annual club photographs. By 1970, the white gloves worn in the earlier shot were not required. The group sponsored a Girl Scout troop and raised money for local charities. The club members periodically teamed up with the area's men's club for joint meetings and presentations. The club met in members' homes, Woodside Elementary School, and at the Forest Hills Recreation Center. Other women's organizations in the area included the Bryn Mawr Mothers' Club, formed in 1926; the Bryn Mawr Junior Mothers' Club, formed in 1931; and the Mothers' League of Bryn Mawr Farms, Chapters I, II, and III, formed in 1948, 1950, and 1956, respectively. Once a year the mothers' club chapters held a joint social.

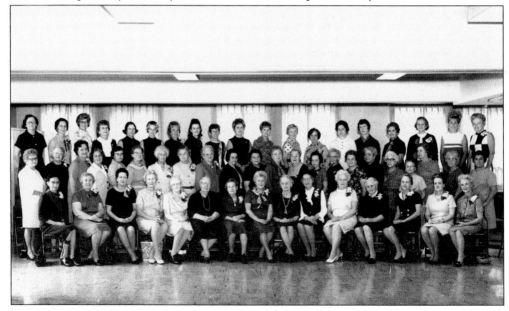

Seventeen women met in the Edgewood Acres home of Mrs. Homer Fritchenman on November 12, 1920, and the Woman's Club of Forest Hills, Inc., was born. Mrs. C. E. Skinner was president. The women's club helped the community and promoted patriotism in the midst of World War II. The brochure pictured here was from the October 20, 1944, Dessert Bridge and Fashion Show fund-raiser. The event was held at the Schenley Hotel in Oakland. Proceeds benefited area hospitals, the USO, the Rankin Christian Center, and the Forest Hills Library. The back cover had an advertisement encouraging citizens to buy war bonds. The page below is a sample of the advertisements from event sponsors. None of the businesses listed on this page are still in operation; however, descendants from the Kennedy and Cost families own similar businesses in the area in 2006.

Woman's Club
OF FOREST HILLS
Benefit

"WE BUILD OUR FUTURE WITHIN OUR HOMES"

Dessert Bridge and Fashion Show

OCTOBER 20, 1944 SCHENLEY HOTEL

The women's club dedicated its one-story clubhouse in 1950. The $14,000 mortgage was burned in 1956. In 1990, upkeep became too expensive and the building was sold. This photograph of unidentified club members was taken in 1990 at the last luncheon held at the clubhouse. The women's club is still active in philanthropy with scholarships and donations to local organizations such as the volunteer fire department.

The Women's Club of Forest Hills turned 50 in 1992, and all current and former members were invited to a June 14 celebration tea at the Frick Fine Art Museum. Museum rules prohibited any photographs. The huge turnout included former presidents Charlotte Coltman, Louise Hickox, and Mildred Roose. This photograph was taken at a late-1950s or early-1960s square dance. Bill and Virginia Fetterman are in the front row, at the far left.

The Garden Club was formed in 1923 and after a brief hiatus from 1926 through 1929 reformed. In 1939, the group became the Garden Club of Forest Hills. The members help maintain the gardens in Forest Hills Main Park, as well as flower boxes in and around the borough office and magistrate office. The Late Bloomers, an offshoot of the garden club, will celebrate its fifth anniversary in 2007. It sponsors the summer farmers' market and tends the flower beds in the Ardmore Boulevard median strip. Above, Mayor Ray Heller Jr. is shown presenting a proclamation to Linda Leasure-Maddox. The photograph at right is the Hillside Garden marker located in Forest Hills Main Park. The garden club established the garden in 1993.

Bryn Mawr Farms Girl Scout Troop 112 is pictured in the 1930s. In the 1960s, the borough had numerous other troops, including Brownie Troop 657 and Girl Scout Troops 240, 266, and 1532, which met at Forest Hills Presbyterian Church. Troops also met at Woodside Elementary and Atlantic Avenue Schools. Since 1993, local Girl Scout troops have participated in the Helping Hands Food Drive, in conjunction with Hope Lutheran Church.

The Junior Troop 112 from the Bryn Mawr area was photographed in the mid-1960s. Mrs. Keffer led the troop. Those identified in the first row are, from left to right, starting with the third from left, Rosemary Fox, Gail Evans, Deborah Furganic, Kathy Evans, and Beverly Bumba. In the second row, Laurie Henderson is pictured at the far right, and in the back row, Agnes Jackmeyer is in the middle.

108

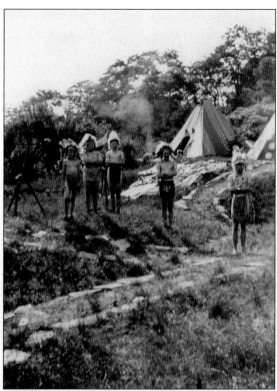

Forest Hills has had many Cub Scout and Boy Scout troops over the years. Many have held meetings at Forest Hills Presbyterian Church, including longtime Troop 90. In 2003, Troop 90 posthumously recognized its first Eagle Scout, Forest Hills attorney William McKee, for his lifetime achievements. His family accepted the award.

Troop 90 remains active in the area with Jack Russell as the scoutmaster. These two photographs from the 1940s are of local Boy Scouts camping on the ground that would later become Churchill Area High School and Churchill Elementary School.

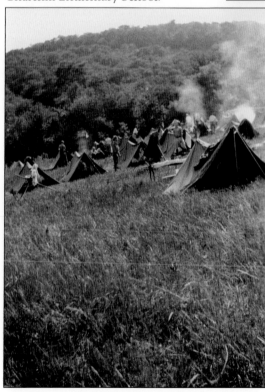

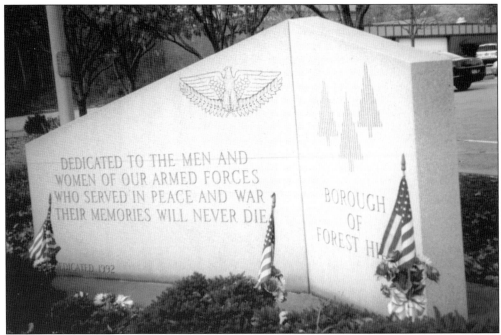

The Lions Club erected this stone memorial in front of the Forest Hills Municipal Building in 1992. Help came from Rochez Brothers Concrete, Philips Monument Company, and Mele and Mele and Sons Landscaping. The inscription reads, "Dedicated to the men and women of our armed forces who served in peace and war. Their memories will never die."

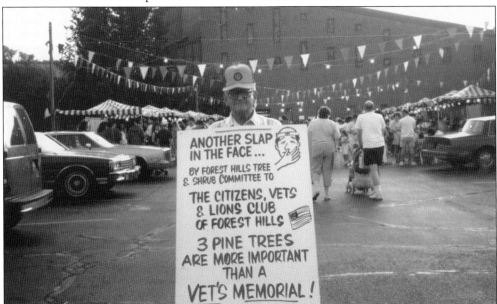

The idea for a memorial was popular, but with some conflict; the council property committee denied permission to place the memorial in front of the municipal building since it would necessitate the removal of three pine trees that represented the borough logo. Lion Mike Vacsulka wore a sandwich board as he picketed for support at shopping centers, at the municipal building, and as mass was letting out at St. Maurice Church.

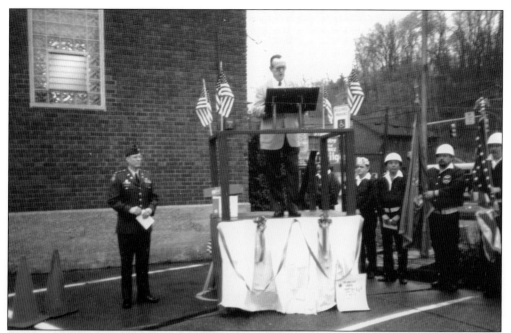

The council eventually gave its approval for the municipal building location. On Veterans Day, November 11, 1992, the memorial was dedicated. Among the honored guests were Mayor Elmer Incheck and Judge John J. Brosky. Local VFW members honored the Lions and the borough by raising the flag. Lions Club secretary/treasurer Jim Walton, pictured on the podium, welcomed everyone and handled the introductions.

Since Forest Hills is a "Tree City USA," it was only natural that the three pine trees at the root of the veterans memorial conflict survived. It took a lot of planning, and a great deal of care, but the trees were relocated a short distance to Ryan Glen Park behind Forest Hills Presbyterian Church.

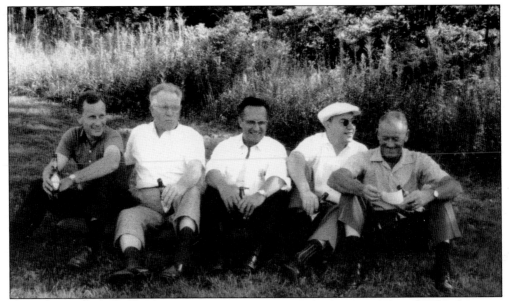

Local businessmen formed the Forest Hills Rotary chapter in April 1947. As of 2006, the group is still active, with weekly breakfast meetings at Drew's Restaurant. The first club president was Harold Kirk. Robert Brindley is the only charter member still active in the group. Pictured at a 1940s picnic at Meister Park are, from left to right, Rotarians Bill Fetterman, Andy Uram, John Dicoskey, Anthony Brucker, and unidentified.

In the early 1970s, the Rotary fund-raisers helped start the Pittsburgh Eye Bank. Rotarians signed up over 1,000 residents to be cornea donors. The group's financial support made one of the first cornea transplants in the area possible. Pictured at a 1971 Community Days celebration are, from left to right, Bill Beiden, Bob Fetherlin, Stan Thomas, Dick Squires, Fred Kirchman, Leroy Zauada, Bob Kim, John Dicoskey, and Mike Silbaugh.

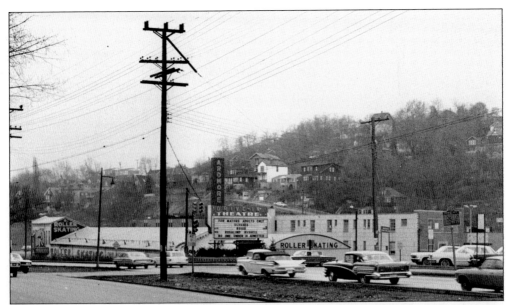

Skaters gathered at the Ardmore Roller Palace from the mid-1930s through 2005, when the rink closed. A former streetcar barn, the rink was renovated and rebuilt several times. The stand-alone building's original concrete floors were replaced with wood, resulting in fewer broken bones. The original structure was torn down in 1969 and reopened in its new location under the Cost Building in 1972. This photograph shows the building in 1968.

Residents who preferred indoor sports skated at the Ardmore Roller Palace or bowled at the Forest Hills Auditorium. The Forest Hills Women's Club sponsored youth dances in the 1950s and movies for children in the 1960s. When Monroeville Mall opened in the early 1970s, residents ice-skated at the mall's rink. Pictured practicing in the 1940s for the *Johnny Rollman High Hat Roller Skating Review* are Lorraine Brucker (Matusz) (right) and Ronald Black.

Forest Hills residents enjoy outdoor recreation. In the 1920s, they swam in a reservoir below Westinghouse Research. In the 1930s, they golfed at the Formas Club. Ice-skating in Main Park was popular through the 1960s. Bobsledders in this late-1920s or early-1930s photograph are, from left to right, Manus Campbell, Charles Campbell, James Mackin, Jefferson Boney, Wilbur Beavers, Joseph Cain, William Makin, Thomas Powers, Nelson Beavers, and John Campbell.

Adults in the borough have always tried to improve recreation facilities and programs. There are records of meetings in 1954 to discuss developing a swimming pool and tennis courts. Improvements and changes were planned and implemented throughout the 1960s. Oblivious to any formal planning, these Edgewood Acres children ran a lemonade stand in May 1966. They are, from left to right, Patty Wyche, Jeff Gilbert, Philip Wyche, and Lynn Jameson.

Annual yard sales have been a tradition for many years in areas like Edgewood Acres and the LeBeau Pike/LeGrande neighborhood plan. The borough began sponsoring an annual flea market/craft show at the Westinghouse Lodge early in the 21st century. Pictured at a 1966 Edgewood Acres yard sale are, from left to right, Patty Wyche, Erin Gilmore, Philip Wyche, Roz Wyche, Jeff Gilbert, Lynn Jameson, and Margaret Gilmore.

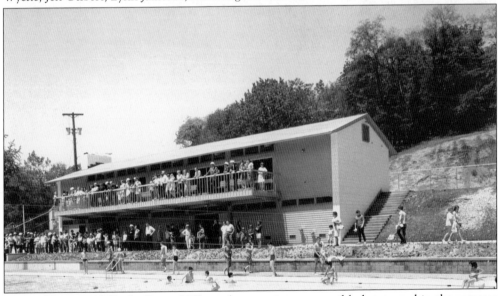

Pictured here in 1969, the Forest Hills pool, recreation area, and lodge opened in the summer of 1968. Local clubs contributed to the success of the pool. The Forest Hills Women's Club, for example, donated $1,000 to fund a public address system. During the late 1960s and early 1970s, the borough sponsored an arts and crafts festival at the lodge. The lodge is used year-round for events, parties, and classes.

Forest Hills Park has been the site of countless family picnics and reunions since it opened in 1934. It has also been home to various summer recreational programs, including arts and crafts camps and Fun in the Park programs. The recreation department also has a summer concert series held at the Westinghouse Recreation Center Pavilion. This photograph was taken in Forest Hills Park in the early 1980s.

As of 2006, in addition to Main Park, Forest Hills has five other parks: Cliffwood Park on Marwood Avenue, Forest Woodlawn Park on Avenue L, Koch Park on Atlantic Avenue, Ryan Glen Park on Cascade Road, and Bright Park on Sherwood Road. Bright Park is pictured here in 1973, with an unidentified child. Alice Bright Stott gave the park to the borough in 1964, in honor of her father, Graham Bright.

Borough children wait eagerly for the fire whistle to sound at 6:00 p.m., kicking off the annual Halloween celebration. Borough police, fire, and rescue personnel can be found cruising the streets passing out candy and safety reflectors. These 1960s trick-or-treaters from Bryn Mawr are, from left to right, Gretchen Milton, Tommy Wick, Danny Wick, Wendy Livolsi, Ann Wick, and Jay Wick.

Eagle Scout Wesley Wise completed his Eagle Project in 1989 by building a bird sanctuary on Woodside Road near Wilkins Road. The project included building and installing birdhouses in the wooded lot. A hand-hewn sign on the site reads Bird and Wildlife Refuge, Woodside Site. Bryn Mawr resident Loxley Bowker also enhanced the area's wildlife with his extensive gardens. Bowker, Kathy Evans (left), and Gail Evans are pictured in the 1960s.

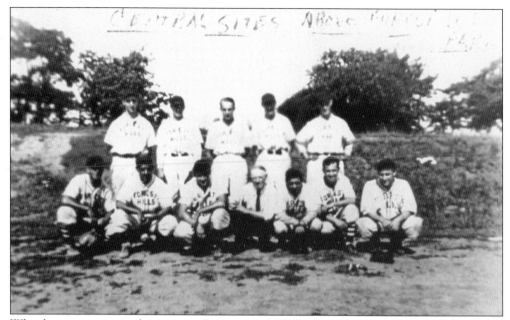

What better way to spend a summer afternoon in 1939 than to play baseball? Central Sites (now the location of Trinity Christian School) was home field for the Forest Hills baseball team. Manager Joe McGuigan (bottom, fourth from left) led players like Ed Sanders (top, second from left), Fred Pferdehirt (bottom, third from left), and Vinny McCoy (bottom, second from right) against area municipalities.

Parents in Forest Hills have long recognized the value of sports and play to health and happiness. Lindsay Sullivan, then seven years old, is shown in this 1993 photograph, at bat in Koch Park. Known only as "the Red Team," Lindsay and her friends were part of the Chalfant Girls' Slow Pitch Softball League.

Forest Hills boasts two homes designed by world-renowned architect Frederick G. Scheibler Jr. The Braddock Road and Ardmore Boulevard homes feature distinctive windows, built-ins, and art glass. Some Edgewood Acres homes had similar features, including stained-glass windows and dual-access cupboards. In the front row at this Edgewood Acres birthday party are, from left to right, Kathy VanSickle, Heidi Lewis, Ellen Damasio, Gretchen Watson, Joyce McConnell, and Lynn Jameson.

Utilitarian-style houses were built between 1900 and 1930 in the Ardmore and Westinghouse Plans for Westinghouse workers. As Westinghouse's presence grew after the research facility opened in 1916, managers and executives built more upscale homes in Edgewood Acres and Bryn Mawr. Apartment buildings and multifamily homes were built among the houses on Halsey Avenue, Lenox Avenue, and Sumner Avenue. Pictured on Sumner Avenue after a 1944 snowstorm are Roz (left) and Shirley Roth.

Houses in Forest Hills reflect different architectural styles. There are Tudor homes in Edgewood Acres, arts and craft–style in Bryn Mawr, and the mix of Cape Cods, ranches, and Dutch Colonials in the Westinghouse Plan. The houses on Ashley Court, one of the newest developments, in Parkway Heights, reflect the 1990s' modern style. Betty Evans is pictured shoveling snow in 1971 outside her arts and crafts home in Bryn Mawr.

This photograph shows 540 Filmore Road during an early-1940s snowstorm. With over 25 miles of roads to maintain, the Public Works Department works hard to meet the challenges of the season. A 2003 *Tree City Times* reports it took workers 1,500 hours that year to clear the roads, using 2,625 tons of rock salt, 3,000 gallons of magnesium chloride, and 600 tons of antiskid material.

Vintage copies of some women's club publications can still be found. The club supported various local causes with books like the 1954 *A Roundup of Recipes* and the 1958–1961 directory, pictured here. Aside from sales to residents, money also came from sponsors such as Spinelli's Market. More than just a telephone book, the directory, still published (now by the Rotary), remains a handy guide to navigating the borough.

Directory

OF

FOREST HILLS

BOROUGH

1958-1961

SPINELLI'S MARKET

2207 ARDMORE BOULEVARD

BR. 1-0771 PHONE BR. 1-0561

Quality Foods - - - *Delivery Service*

OWNED AND OPERATED BY FOREST HILLS RESIDENTS

WILSON

MOR

On Sunday, May 25, 1986, Forest Hills residents joined over five million people in the Hands Across America benefit. Stretching from New York to California, the human chain wound down Ardmore Boulevard. Money raised by the event, which was sponsored in part by the Coca-Cola Company and Citibank, went to local soup kitchens and other charities designed to fight hunger and homelessness. These two photographs were taken on Ardmore Boulevard, looking east from Lenox Avenue (above) and west from Sumner Avenue (below).

One of Ed Sanders's first jobs was setting up pins at the Forest Hills Auditorium bowling alley, back in 1935. Owned originally by Gus Gasper then Al Koch, the building is viewed in the photograph above looking across the empty lot that would later be home to Gravity Fill and Sunoco gas stations. The auditorium started out with duckpins before graduating to tenpin lanes. Eventually the building housed Wissman's Bowling Supplies. In early 2005, when the building was being sold and then torn down, Sanders asked Robert Wissman for a souvenir of his time working there so many years ago. Sanders was given this Brunswick duckpin from 1935 that was once used at the auditorium.

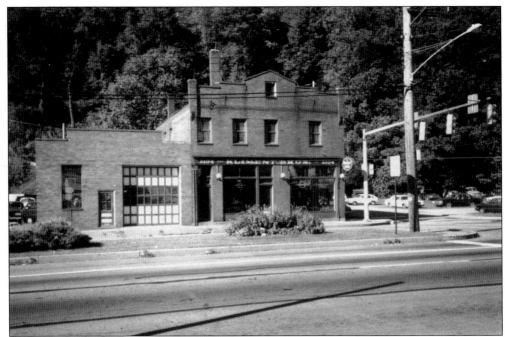

The early-1950s Studebaker Commander convertible, owned by Pete Kliment Jr. and his wife, Rose, was in the window of Kliment Brothers Studebaker gasoline/service station long after Pete and his brother Joe stopped repairing cars and selling gasoline. The sale of the car and its move from the showroom in December 2001 marked the end of an era for both the admirers of the car and the building, owned by the Kliment family since 1905. Pete sold the building in 2003 to a local couple, Crispin Zuback and Holly Zajac, who renovated the building, including the attached apartments and house, and opened an ice-cream shop in the building's former garage. A restaurant is also planned. The building is pictured above, prior to renovation. Below, Pete is pictured with his beloved Studebaker.

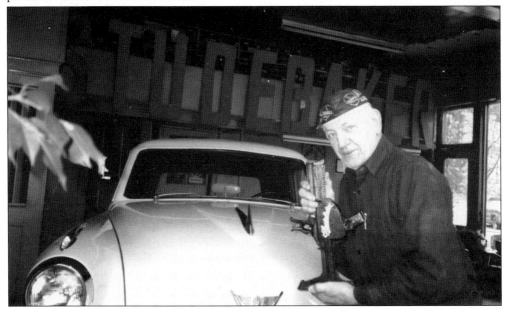

Hawthorne Elementary alumni Jim and John McGregor made the area proud with their successes. John, a former state senator, was one of the founders of the Pittsburgh Penguins. As of 2006, he owns a minor-league baseball team in Connecticut. Jim has served the area as a judge for over 30 years. The McGregor family, pictured in 1994, includes, from left to right, Janice (Wren), Leah McGregor, Jean (Martenson), Jack, and Jim.

Santa and Mrs. Claus are, of course, usually dressed in red. The difference is when they are in green as part of a 1962 Christmas promotion for Sprite soft drink. They once sat in the window of the Thoroughfare supermarket in Ardmore Shopping Center. They now spend every holiday season in the window of Elizabeth Hanzel's Little Dishes gourmet dessert shop. Elizabeth's father, Richard Colella, managed the Thoroughfare in the 1960s.

Forest Hills has been a National Arbor Day Foundation "Tree City USA" since 1986. In the early 1920s and 1930s, the borough took tree care seriously, establishing a tree-planting program. Businesses and residents contributed to the program and planted American elms along both sides of Ardmore Boulevard. Through the 1950s, pin oaks, silver maples, lindens, and sycamore trees were planted. The first tree commission was appointed by council in 1950, and in the mid-1970s, a tree committee, which still exists, replaced the commission. In 1990, a professional arborist was hired. Local students participate in the annual Arbor Day celebration. In the picture above, taken at the fifth Arbor Day celebration in 1991, this unidentified group is holding Tree City USA signs. Borough arborist Ted Gilbert (right) is pictured below at the 2006 celebration with Pennsylvania forestry official Tom Fitzgerald.

It has a funny name but a serious mission. The Forest Hills Flivver is both a vehicle and a nonprofit organization that has been in the borough since the early 1980s. The Flivver transports senior citizens or disabled residents anywhere within borough boundaries, whether it is to the doctor, beauty shop, grocery store, or senior center. The Forest Hills Flivver is an all-volunteer organization. The Flivver's original drivers were all women.

In 2005, Forest Hills erected two concrete markers welcoming visitors. The markers, located on Ardmore Boulevard at the Wilkinsburg and East Pittsburgh entrances to the area, include the newly designed borough logo. The logo celebrates the area's Tree City USA designation and commitment to green space. The logo can also be found on borough letterhead, T-shirts, and the borough's *Tree City Times* newsletter.

ACROSS AMERICA, PEOPLE ARE DISCOVERING SOMETHING WONDERFUL. *THEIR HERITAGE.*

Arcadia Publishing is the leading local history publisher in the United States. With more than 3,000 titles in print and hundreds of new titles released every year, Arcadia has extensive specialized experience chronicling the history of communities and celebrating America's hidden stories, bringing to life the people, places, and events from the past. To discover the history of other communities across the nation, please visit:

www.arcadiapublishing.com

Customized search tools allow you to find regional history books about the town where you grew up, the cities where your friends and family live, the town where your parents met, or even that retirement spot you've been dreaming about.